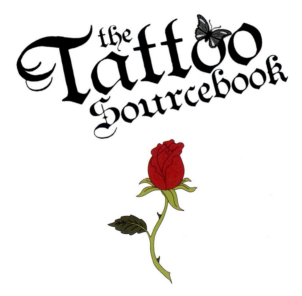

the Tattoo Sourcebook

THIS IS A CARLTON BOOK

Text and design copyright © Carlton Books Limited 2008

This edition published in 2008
by Carlton Books Limited
20 Mortimer Street
London W1T 3JW

Reprinted in 2009
10 9 8 7 6 5 4 3

Material from this book has previously appeared in *Tribal Tattoo Book* by Andy Sloss (Carlton, 2000), *Celtic Body Decoration* by Andy Sloss (Carlton, 1999) and *Mehndi Body Painting* by Zaynab Mirza (Carlton, 1998).

Original mehndi designs on pages 188–253 © Zaynab Mirza 1998
Illustrations on pages 122–87 © Malcolm Willett 2008

A CIP catalogue record for this book is available from the British Library.

ISBN 978 1 84732 189 3

Printed and bound in China

Senior Executive Editor: Lisa Dyer
Senior Art Editor: Gülen Shevki-Taylor
Designer: Emma Wicks
Production: Kate Pimm

the Tattoo Sourcebook

Andy Sloss & Zaynab Mirza

OVER 500 IMAGES FOR BODY DECORATION

CARLTON
BOOKS

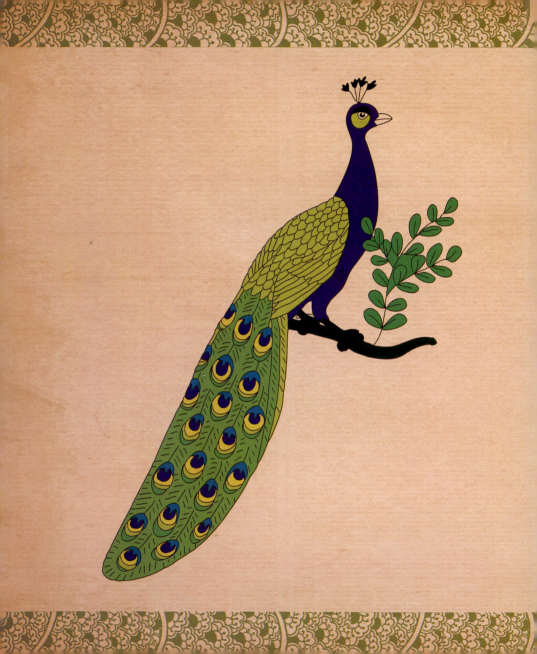

CONTENTS

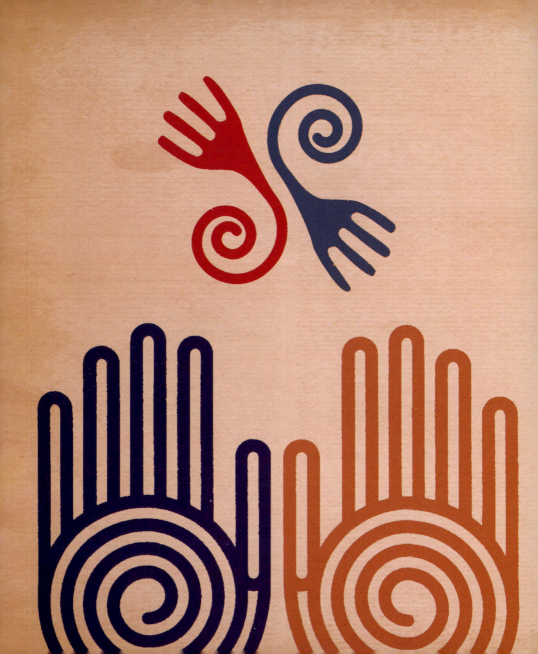

TRIBAL TATTOOS

Many Pacific cultures believe that artworks charge a person with power, both spiritually and socially. The decoration of the body, by tattoo or body paint, acts like a lens for the internal spirit, reflecting and enhancing sacred power. The images can be used to attract the focus of the ancestors, so that the body becomes the channel between the human and spirit worlds. Thus, in these cultures, tattoos were used as a protective shell, as well as badges of social rank.

Although the styles and designs differ from one culture, one set of islands, to another, almost all of them used large areas of solid black, called 'blackwork'. This may have been an aspect of machismo, showing how much the wearer can take, but there were many cultures whose men were tattooed with large rectangular blocks of solid black.

There is evidence that virtually all pre-Hispanic cultures in South America used tattoos or body painting, too. There were different techniques and a wide variety of styles, but they were all used for social or religious purposes, rather than purely for decoration. None of the societies had a written language, apart from the hieroglyphs of the Mayas and the Aztecs, so the images and colours they used were a part of a visual and spiritual language that is still not fully understood today.

The arrival of Cortez and the Spanish in 1519 heralded the end of most of the indigenous cultures, religions and art forms, including tattooing. This means that the best descriptions of the Central American art of tattooing come from those who set out to eradicate it. From these we know that the more tattoos you had, the braver and stronger you were considered, while people who had no tattoos where mocked and scorned. Men and women were both tattooed, with women being tattooed from the waist up in designs that were more delicate than those of the men.

In North America, there were thousands of different tribes before the arrival of the Europeans, each with their own cultures and artistic language. Tattooing and body painting for special occasions appear to have been important to virtually all of them. The term 'redskin' comes from the prevalence of body painting, especially among the Plains tribes. Unlike most of the other cultures described in this book, their use was less for social and spiritual power, and more to do with individual prowess, beauty and respect. Not to be tattooed was a disgrace, but to falsely wear a tattoo was even worse – the offending tattoo would have to be publicly cut off, a punishment that could often be fatal. Many used tattoos for medicinal reasons, such as the Ojibwa, who tattooed the cheeks and foreheads of those suffering chronic toothache or headaches. The practice of tattooing brave warriors was taken a step further by depicting the battles on the warrior himself, so his body became a catalogue of his deeds, for all to marvel at.

One design that was found in body painting throughout North America, regardless of tribe and tradition, was the hand print, usually on the face. This was almost certainly due to the fact that body and face painting was done by the wearers themselves, using a bowl of water

as a mirror, so patterns and designs were only applied where they could be seen and reached by the wearer. A handprint on the face to finish off the work would have been a mark of the individual, not unlike the signature at the bottom of a painting.

The traditional method of tattoo, of marking out designs with black dots, works less well as the skin darkens. For this reason if not any other, tattooing does not have a rich tribal history in central and southern Africa. The equivalent marking of patterns is generally done either by scarification (which makes the designs more visible by making them three-dimensional) or by painting. And in this African societies excel all others. In some tribes every adult has his or her 'make-up kit' with powdered paints and fat for applying it. The sheer range of styles and patterns, the meanings of the images and their colours, is overwhelming.

Some designs are obvious, like the painting of spots all over the body, while others are more symbolic, such as lines on the legs or forehead to represent fast or horned animals. A lot are purely decorative, things of beauty or expressions of the wearer's mood. On the pages that follow you will find traditional tattoos from the tribes of Africa, Europe, the Pacific, and the South, Central and North Americas, as well as some modern interpretations.

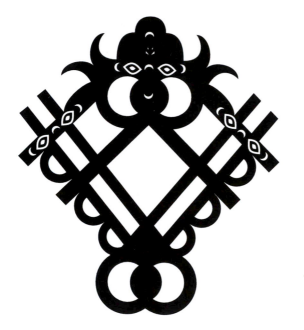

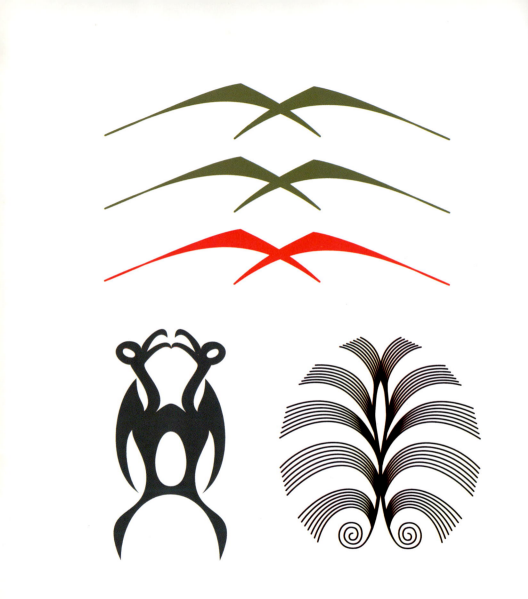

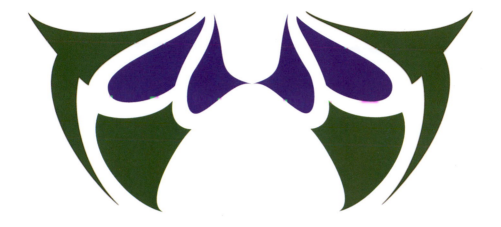

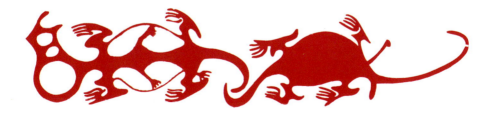

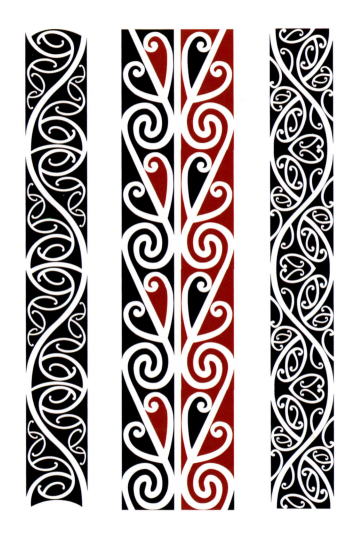

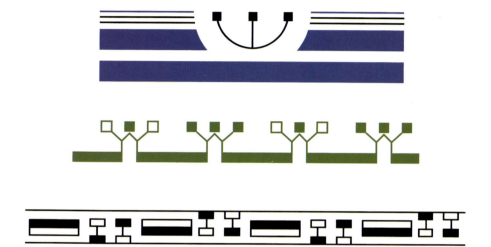

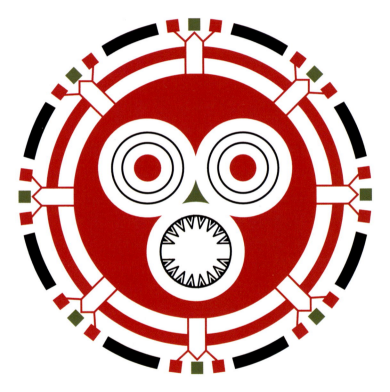

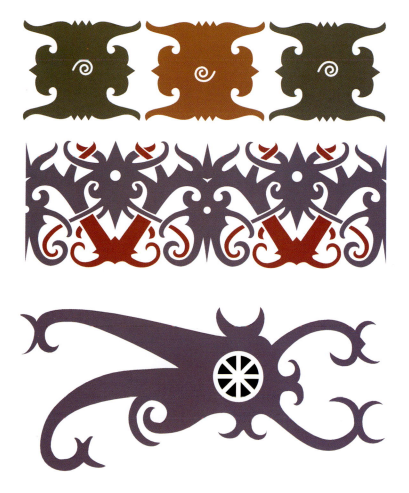

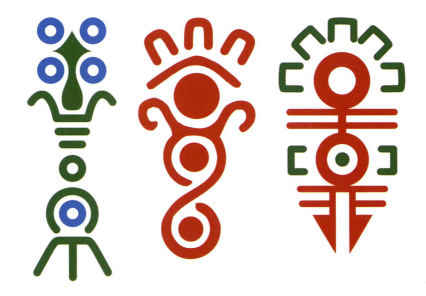

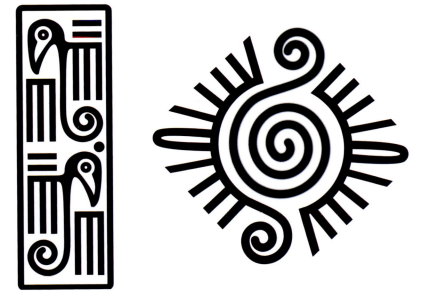

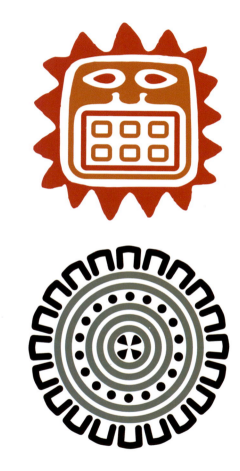

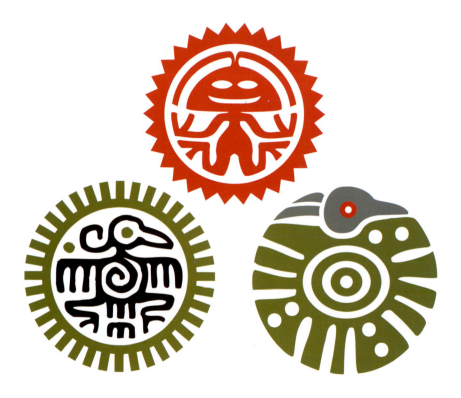

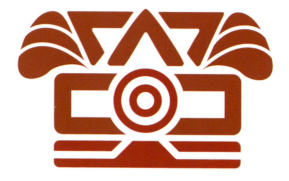

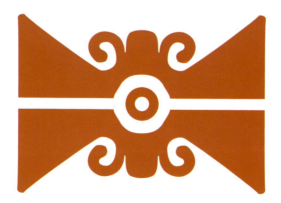

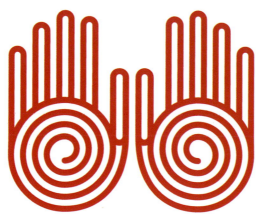

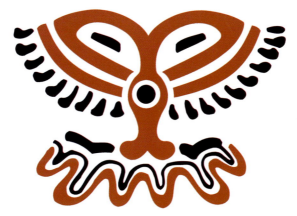

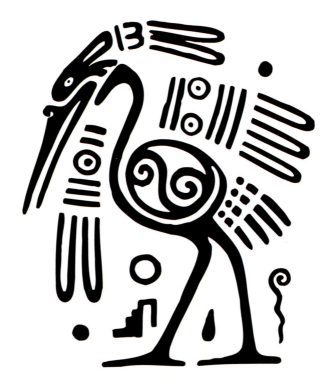

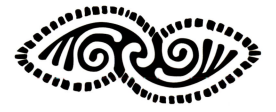

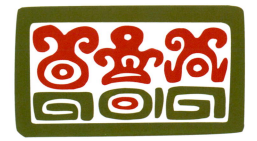

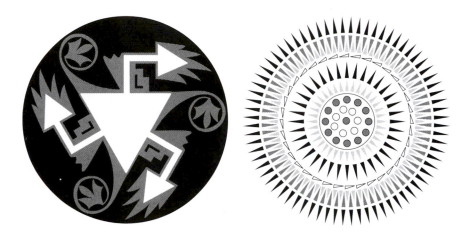

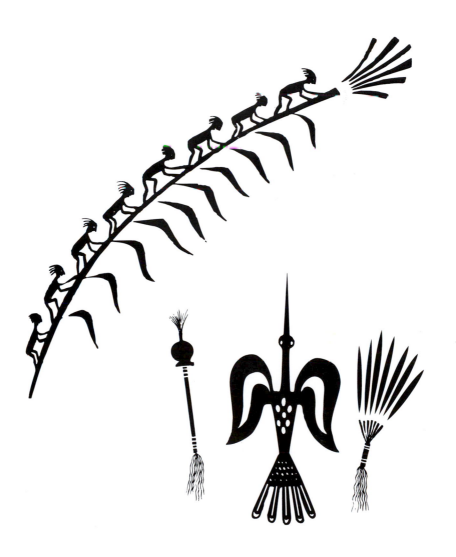

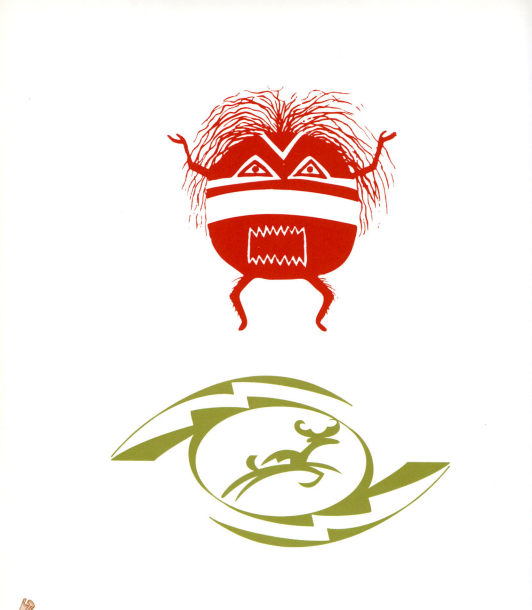

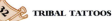

 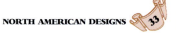

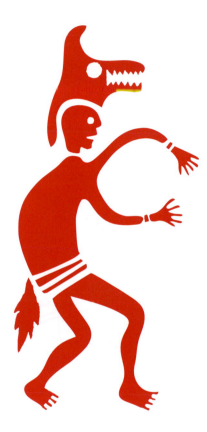

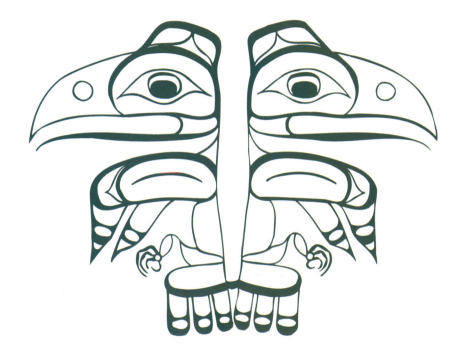

TRIBAL TATTOOS

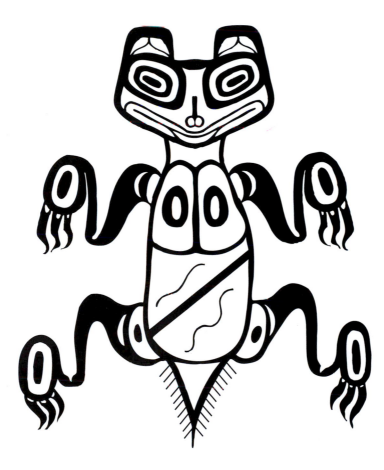

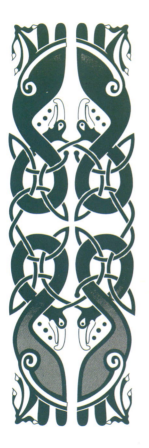

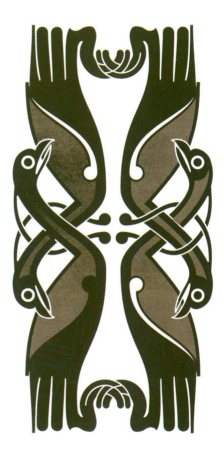

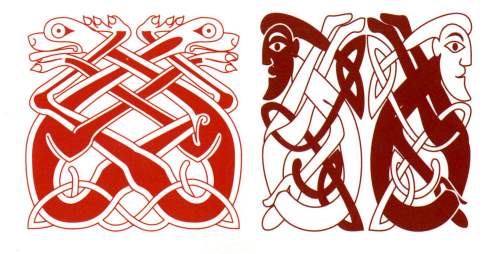

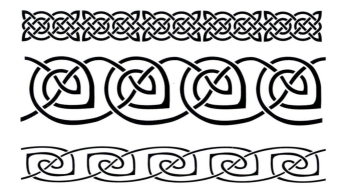

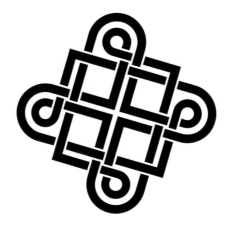

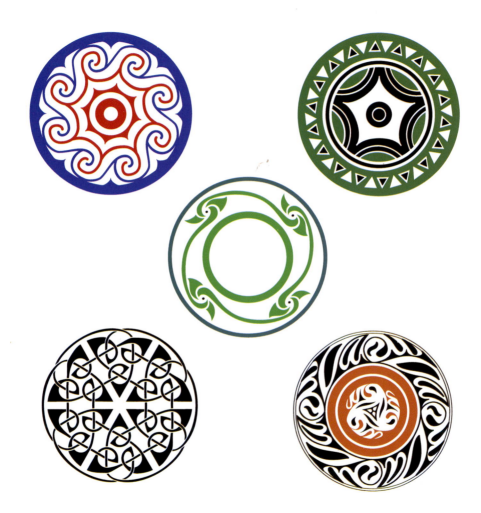

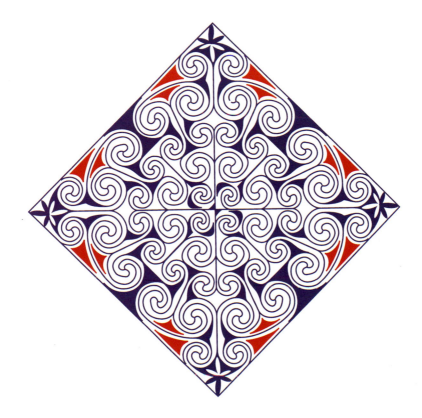

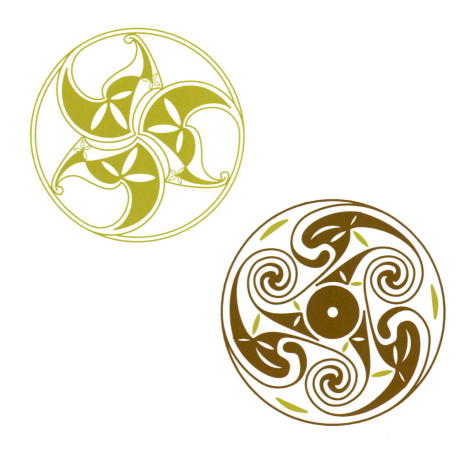

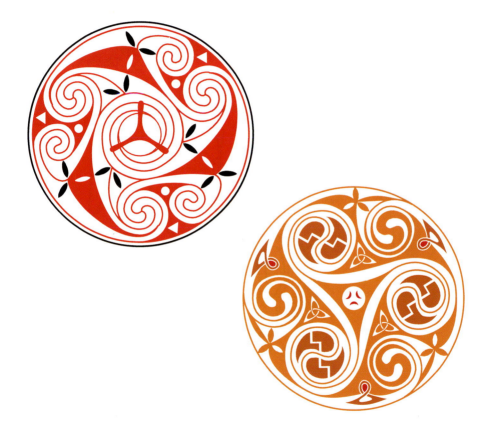

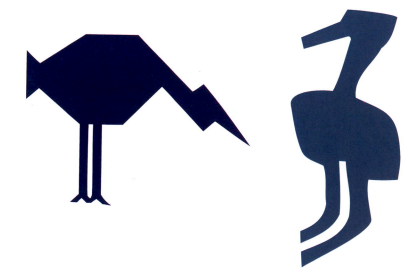

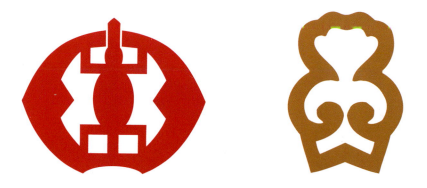

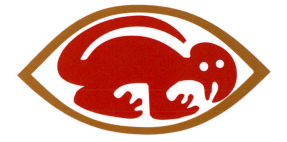

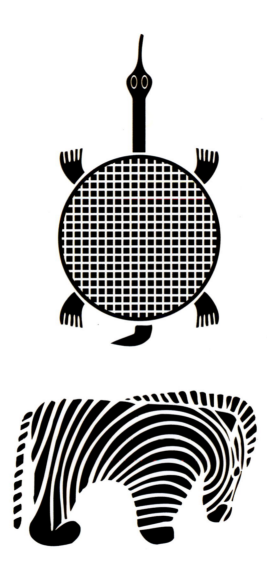

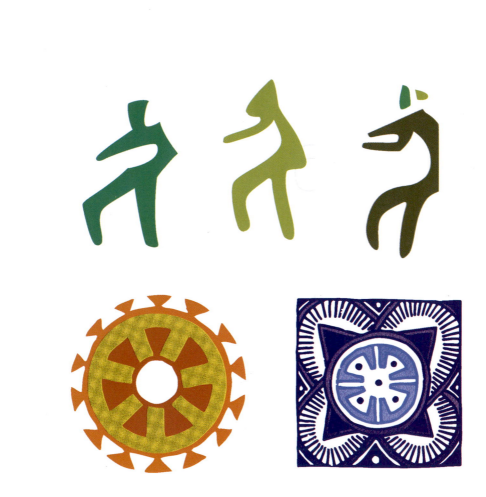

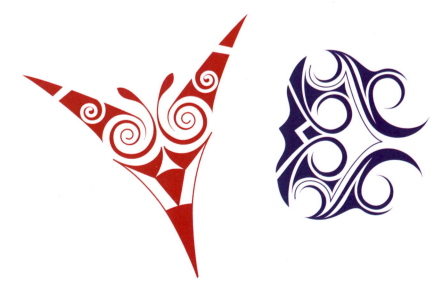

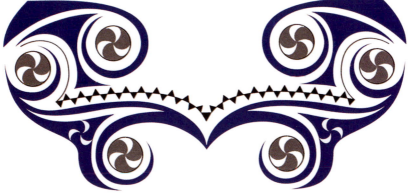

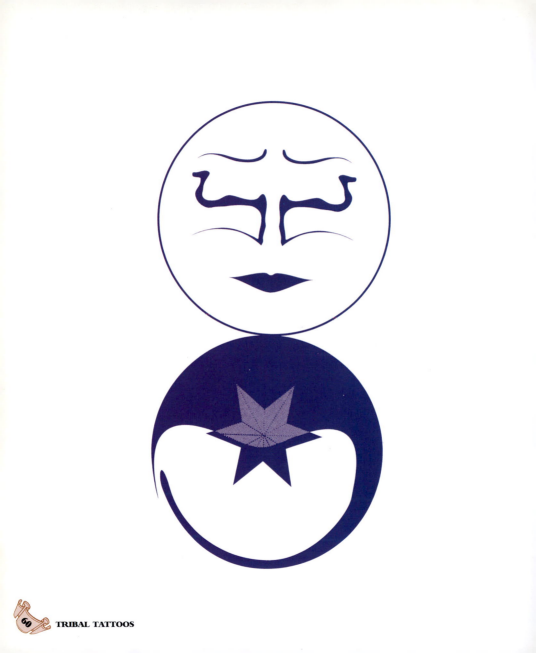

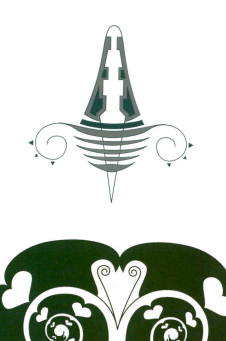

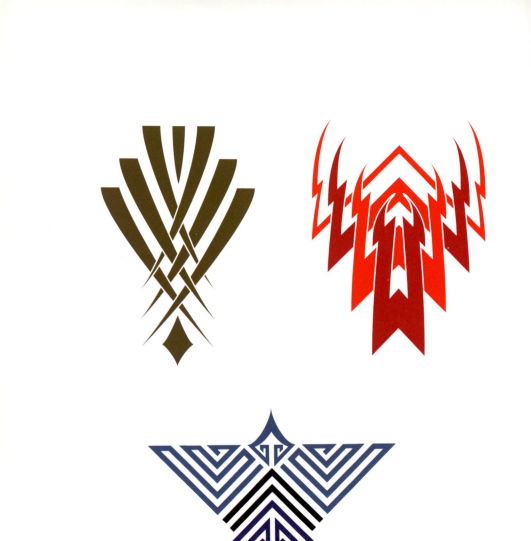

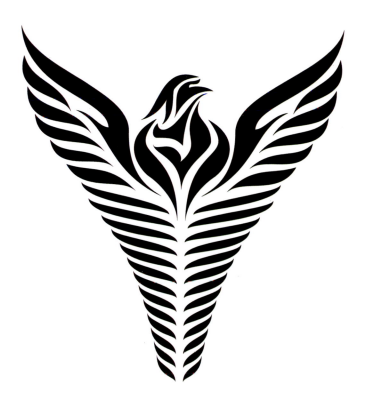

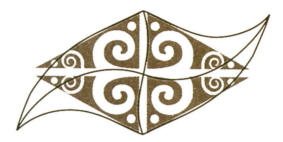

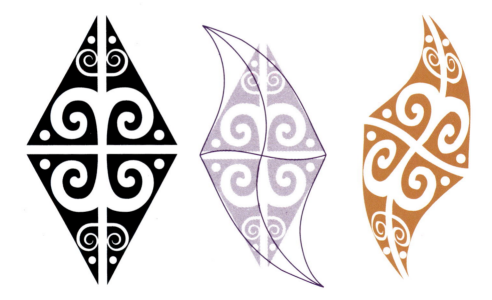

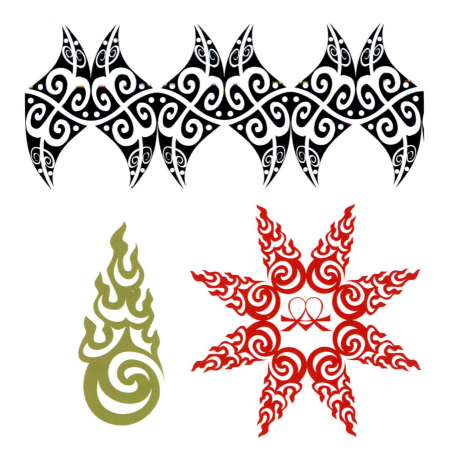

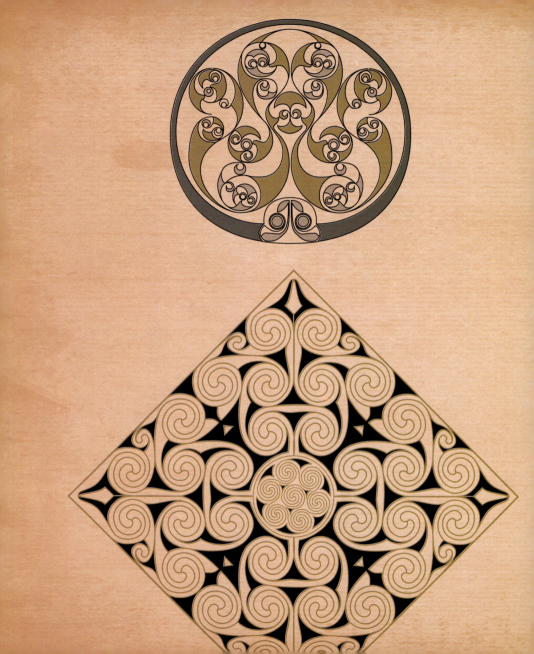

CELTIC TATTOOS

Historical references to Celtic body art date from the middle of the first century BC, when Caesar (whose histories are famous for being more propaganda than accurate description of the events and peoples) wrote in *Gallic Wars*, 'All the Britons, without exception, paint themselves with woad, which produces a bluish colour.' Later references to the Britons painting themselves can be found in the writings of Pliny, Martial, Mela, Solinus, and Herodian in the third century. The first reference to body art as peculiar to the Picts, however, is only found in the seventh century, in the works of Isidore of Seville.

As for the designs themselves, there is much archaeological evidence that the pre-Christian Celts used an astonishing range of spiral patterns, step patterns and symbols of animals and people (though images of people were much more common in Scandinavia and among the Germanic Celts than in Britain). The spirals and step patterns of the early Celts are well documented. Examples of Celtic animal designs survive, for example the Burghead Bull, a stylized image of a bull carved on a stone in Burghead, Inverness. The shape of the hooves and the spiral patterns of the shoulder blades and ear lobes are notable. These features are repeated in most of the great Bibles of northern Britain and Ireland, especially in the evangelists' symbols of the lion and the lamb. That they appear almost unchanged across such a wide time-span and area indicates that they were popular images with a powerful

significance and history in Britain. Bird images, and to a lesser extent dogs, show a similar uniformity in the Bibles. While there are some comparisons with German art of the time, their popularity in Britain implies a local tradition dating from long before Christian times.

It was in borders and decoration that Celtic artists found the scope to show off their skills. Scribes quite quickly dropped as much portraiture and illustration as possible, making decoration the focus of the art. Thus carpet pages were born. These are pages filled to the brim with knotwork, key patterns, interlaced animals, spirals and other traditional Celtic motifs suitable for the hours of contemplation that were the staple diet of the Columban monk. Centuries earlier the Celts had taken basic fret and step patterns and for some reason rotated the grid. Instead of on traditional horizontal and vertical planes, all the setting-out lines were drawn on the diagonal. This dramatically increased the number of possible variations and meant that the edges of the page had to be completely redesigned, which led to the evolution of the distinctive Celtic key pattern.

Over the next thousand years Celtic art disappeared, even from countries outside the Christian empire. The Vikings had worked in a similar style for some time, having developed it from the same roots, and continued to design knotwork and interlaced snake and bird images. This style, known as the Urnes style, used much thinner lines than did Celtic art, and much of the balance, symmetry and beauty of form were lost.

It was through the nineteenth-century interest in archaeology and history, as well as the Victorian fashion for decoration, that Celtic art was rediscovered. Pioneering work by J Romilly Allen and George Bain led to the publication of Bain's book *Celtic Art: The Methods of Construction*, in 1951. This started the modern interest both in creating Celtic works of art and in understanding and appreciating them.

By the 1970s Celtic tattoos had started to become popular, first in Britain, then further afield. While tattooists were getting to grips with the form, almost all the designs were copied from George Bain's book, but as artists became more confident in their abilities, they developed new and increasingly complex originals. Nowadays there are tattooists around the world who will make you a unique and fascinating design if you have the patience, nerve and money. Increasingly popular are Celtic designs superimposed on zigzag, lightening-bolt-like lines, drawing inspiration from a wide range of sources – from Maori body art to the works of the Swiss surrealist H R Giger. So the Celtic tradition of assimilating and adapting styles from other cultures continues, and now it is your turn to add to the body of Celtic art. Create and enjoy.

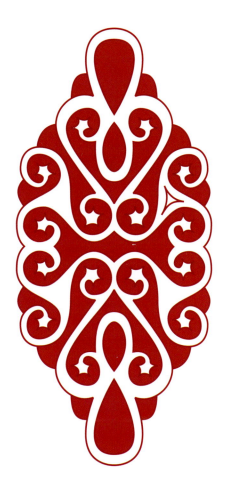

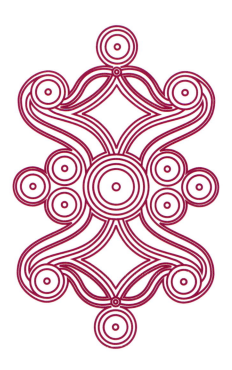

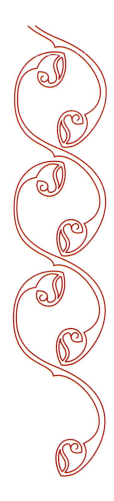

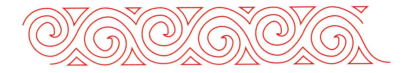

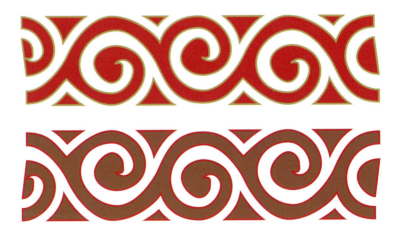

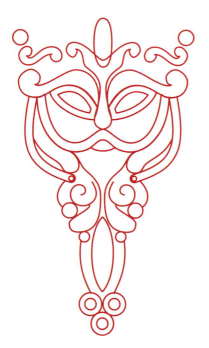

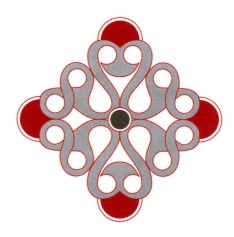

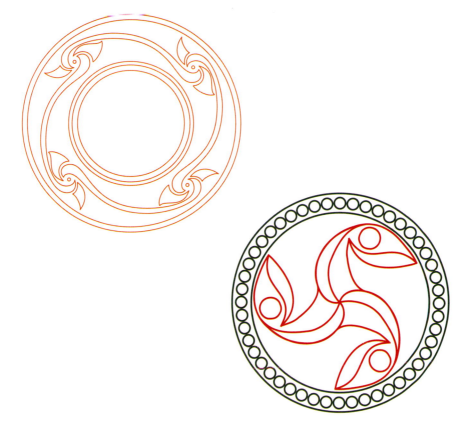

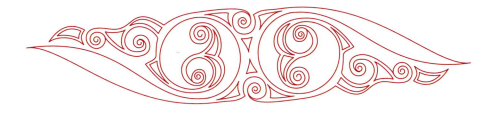

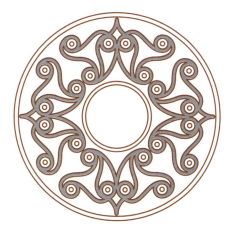

CELTIC TATTOOS

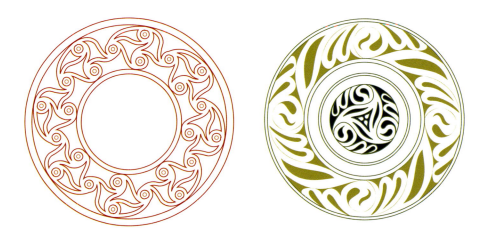

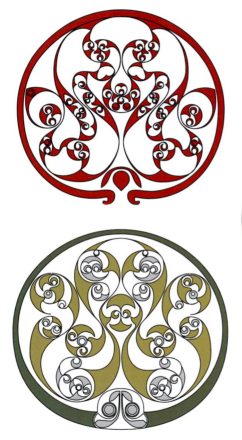

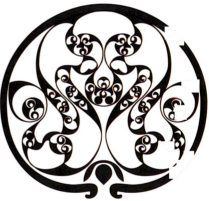

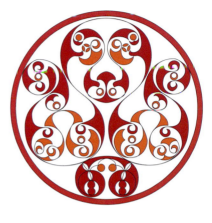

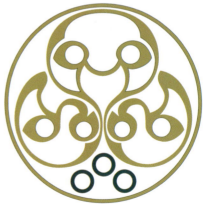

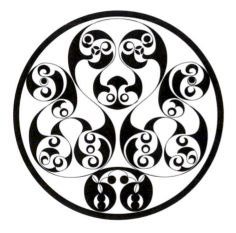

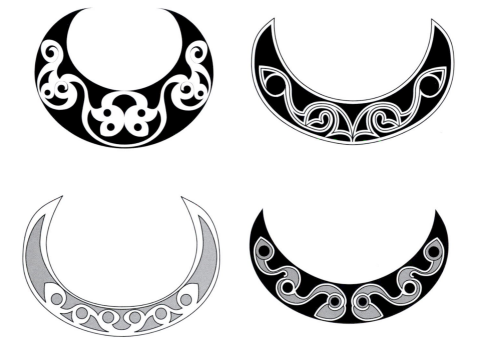

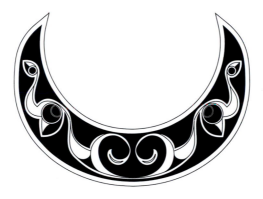

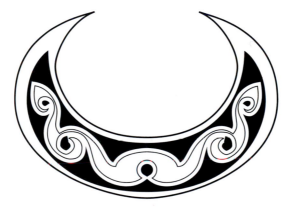

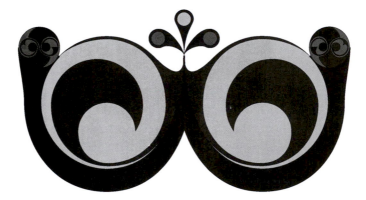

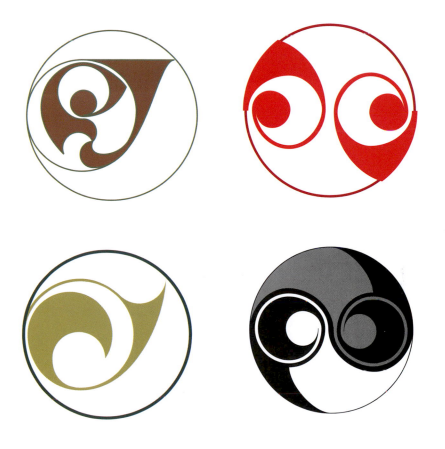

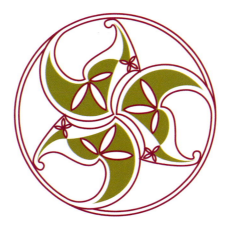

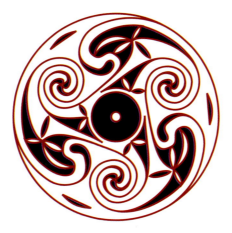

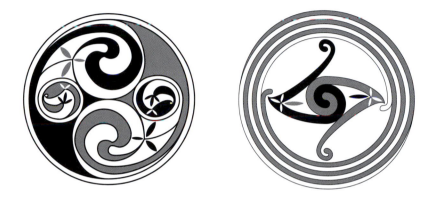

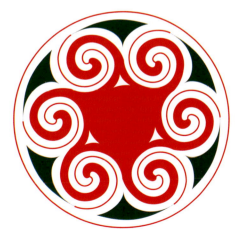

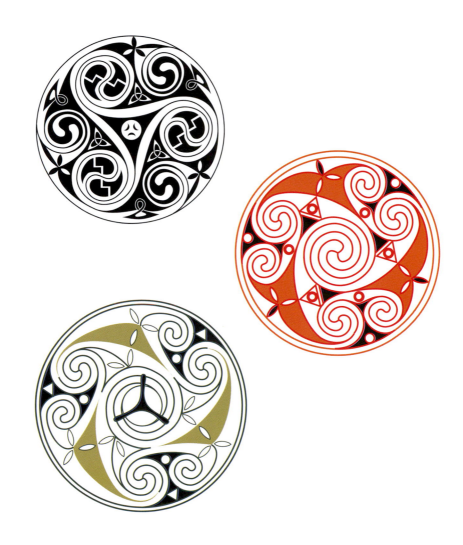

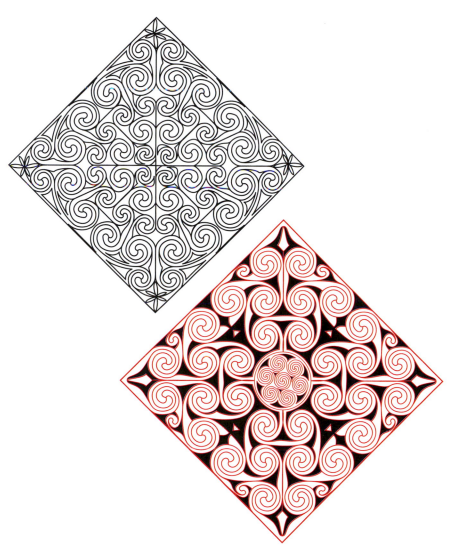

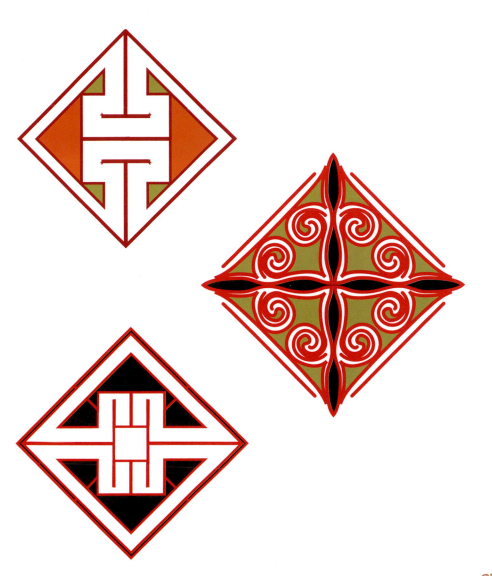

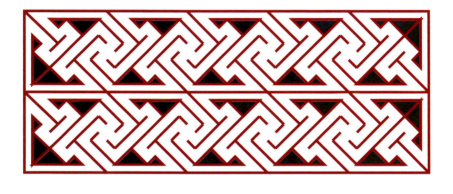

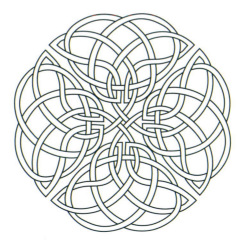

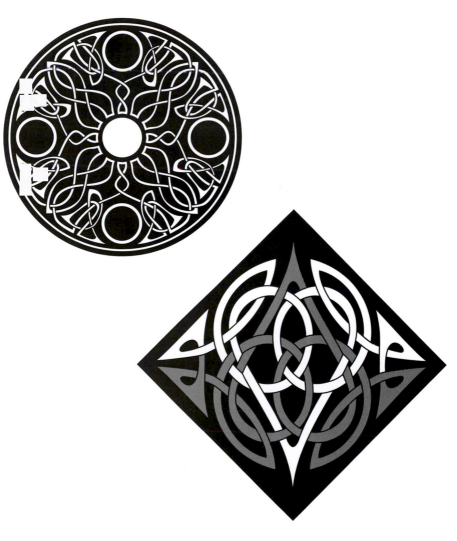

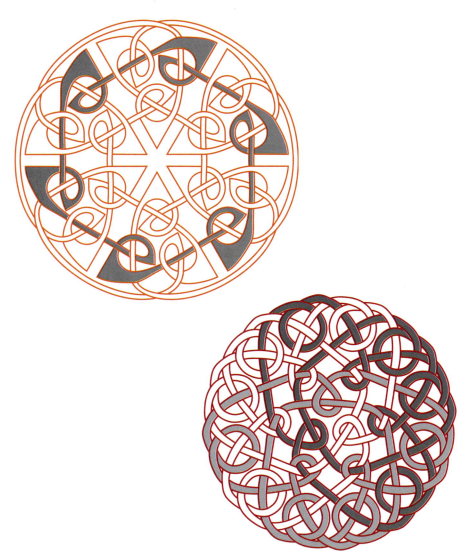

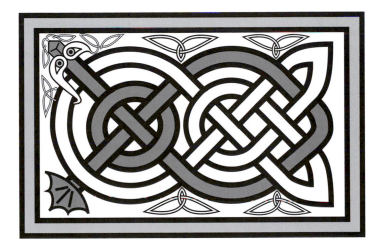

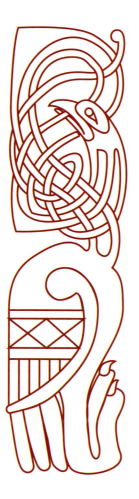

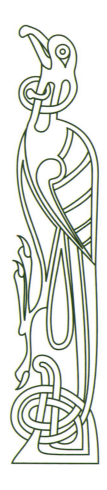

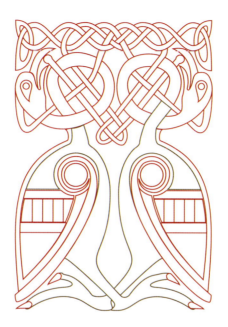

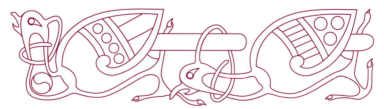

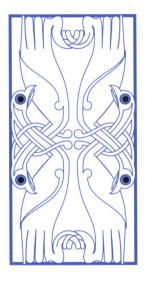

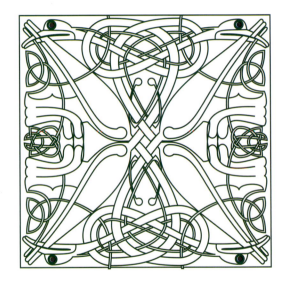

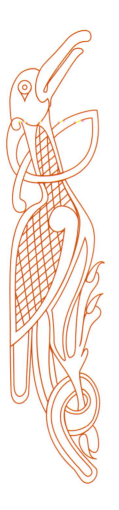

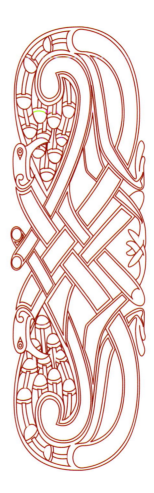

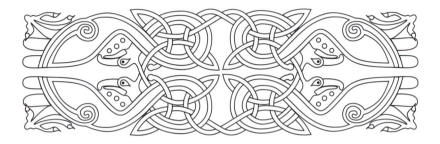

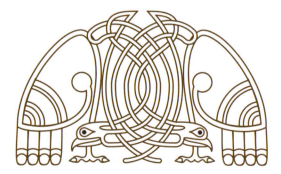

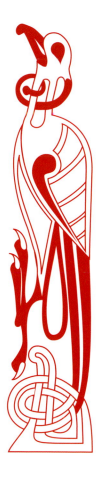
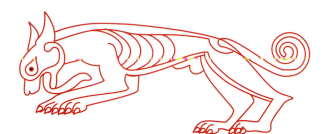
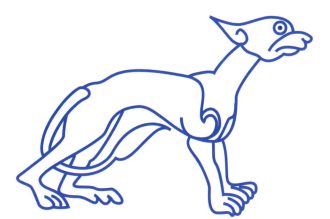

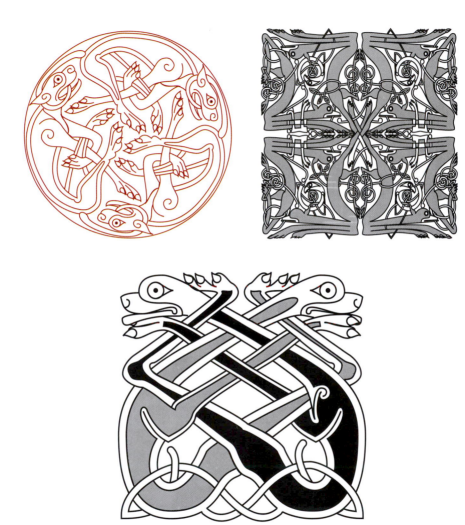

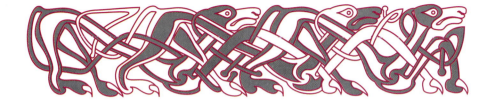

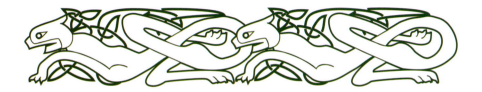

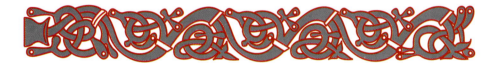

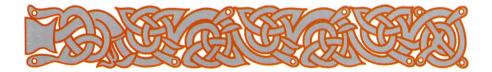

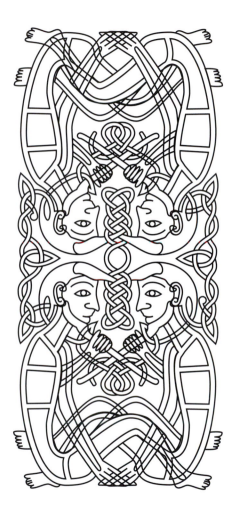

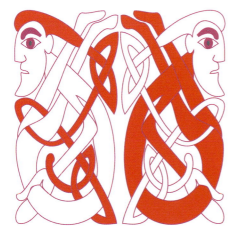

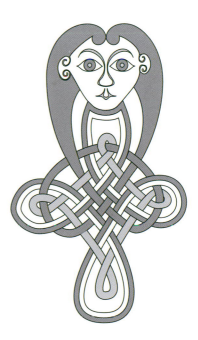

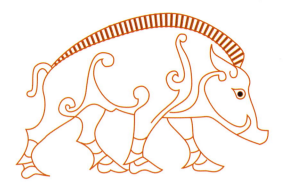

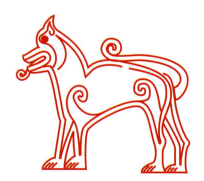

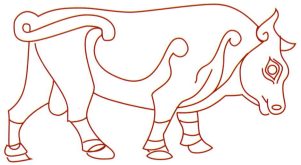

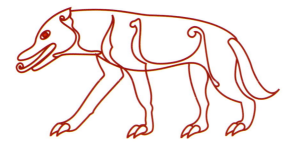

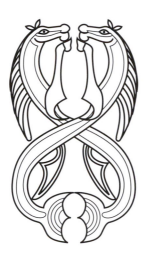

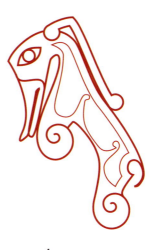

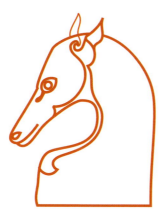

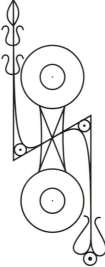

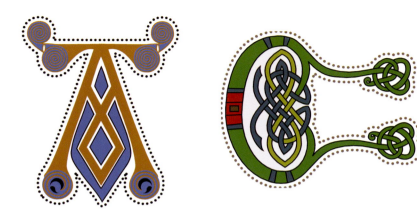

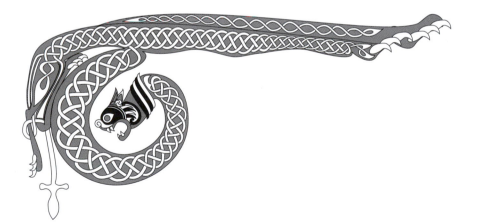

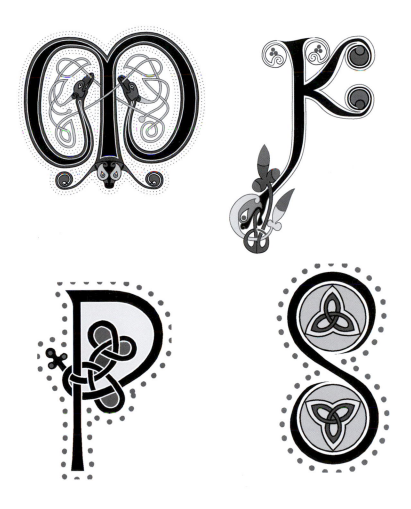

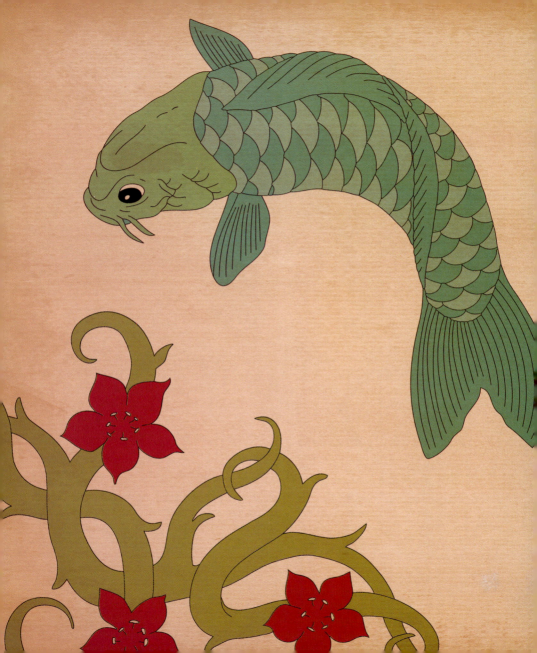

NATURE TATTOOS

From sea creatures to jungle animals, roses and butterflies to the sun, moon and stars, the natural world has long been a source of inspiration to the tattoo artist. Inherent in such imagery is the enduring power of a world outside the human one, a world that operates on it's own particular set of rules rather than the order humans can impose. As a result, tattoos of these images connect us to a greater, universal force beyond us.

Some people are drawn to animal images because of the mythology or symbolism attached to a particular animal or the qualities associated with an animal, such as strength, nobility, courage or cunning, that they imagine themselves to possess or believed they might acquire by wearing the tattoo. For example, snakes are often associated with the life cycle – creation, destruction and eternity – and in Central American folklore, flying insects are said to be the souls of the dead revisiting this world. Other natural forms, such as butterflies or flowers, are admired for their beauty. Flowers are symbols of youth, vitality, new life and victory over death. The colours of flowers have a symbolism of their own, with red indicating passion, love or even the blood of Christ, whereas white flowers signify purity and blue flowers denote devotion or sometimes secrecy. Some images, such as the cherry blossom, lotus flower or water lily, crossed over from Eastern tattoo traditions to Western ones. Look at the following pages, and the world around you, for your own tattoo inspirations.

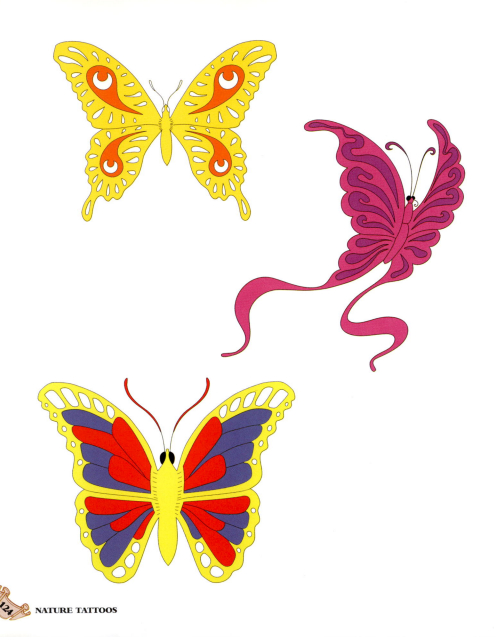

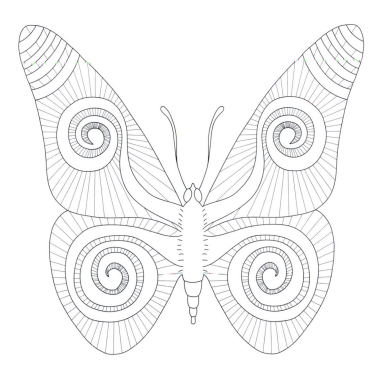

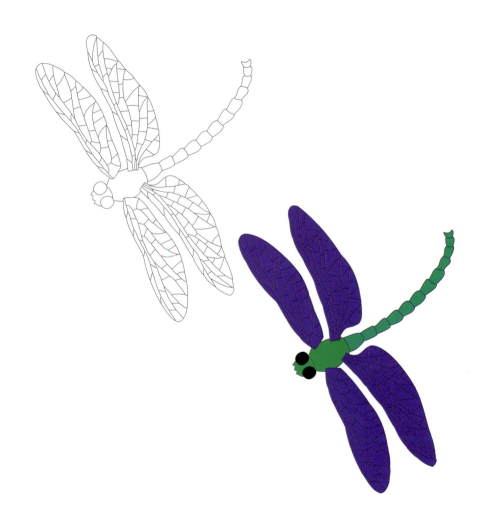

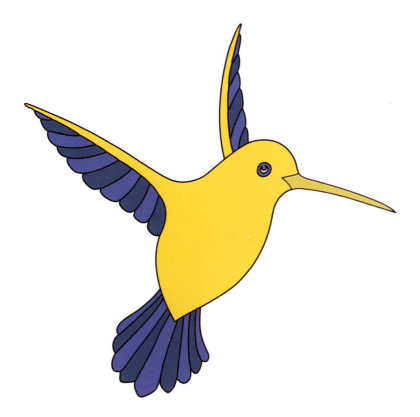

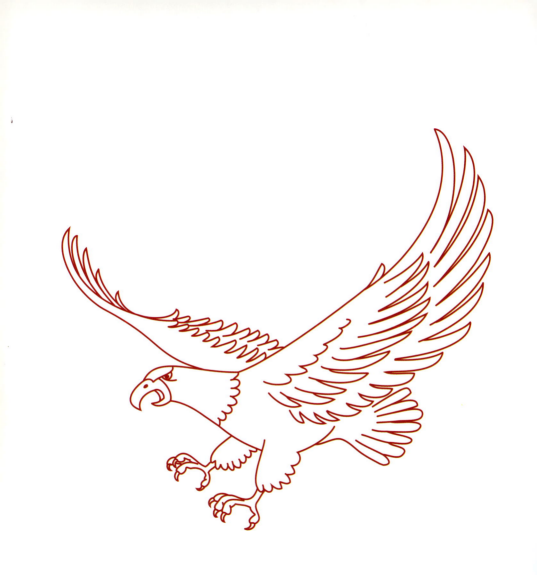

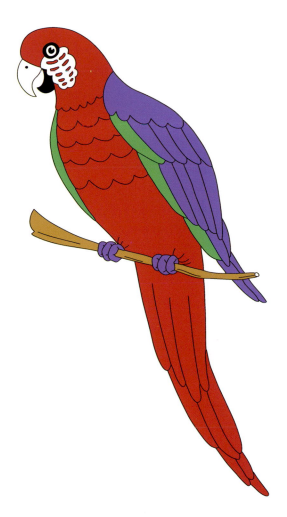

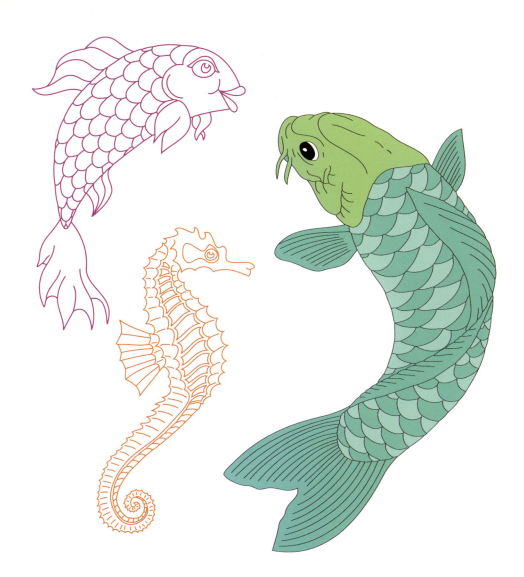

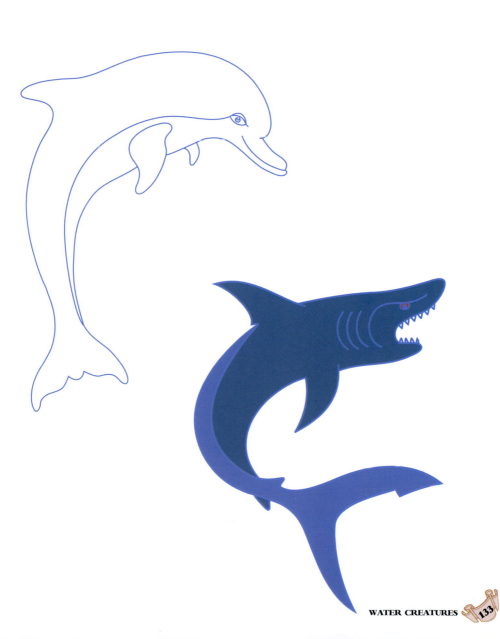

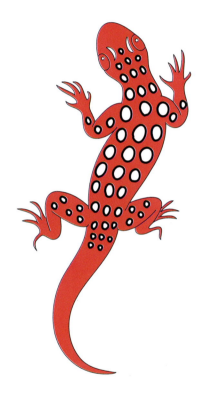
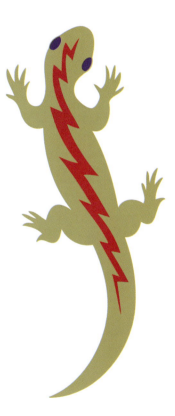

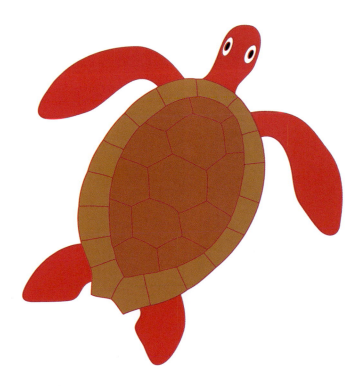

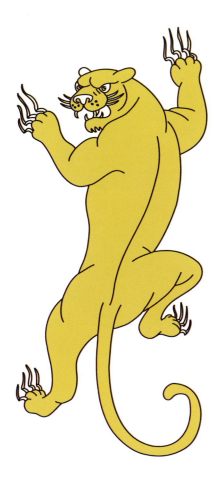

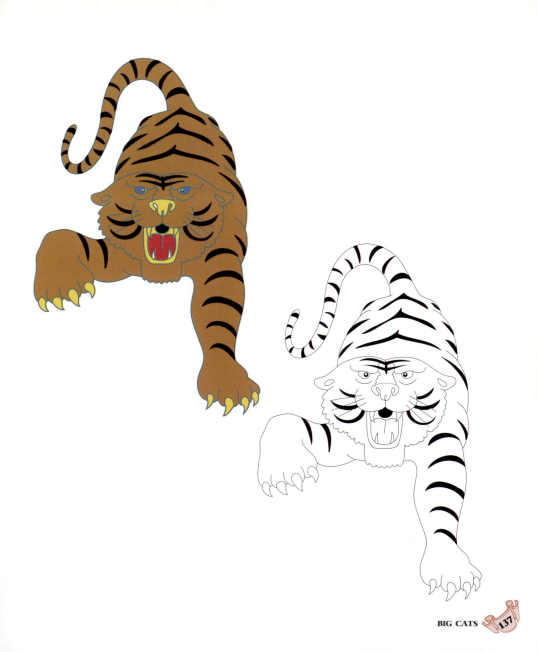

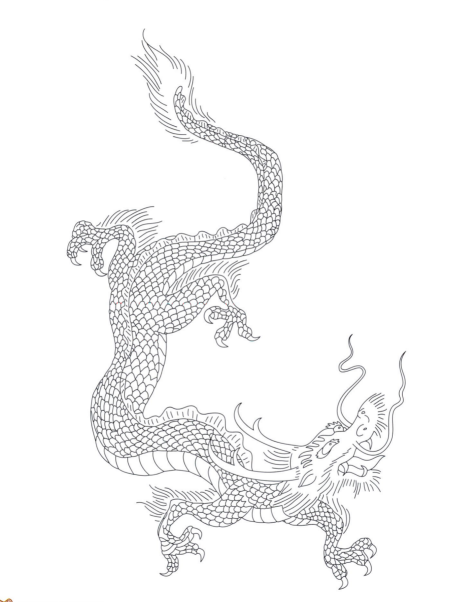

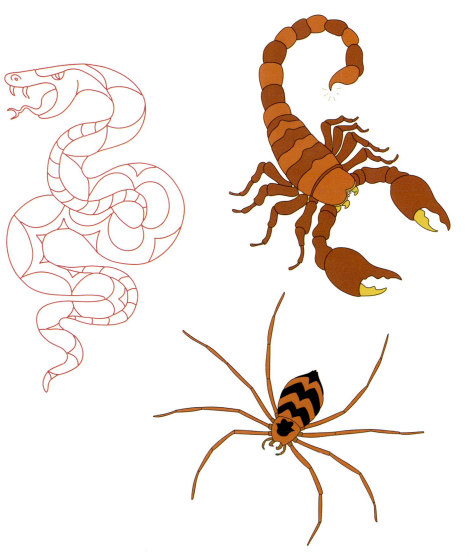

DRAGON, SNAKE, SCORPION AND SPIDER 139

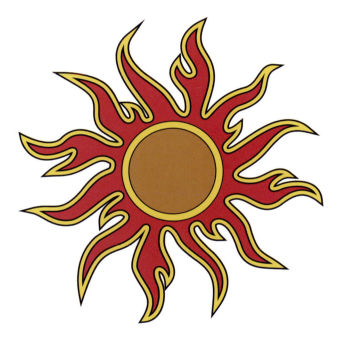

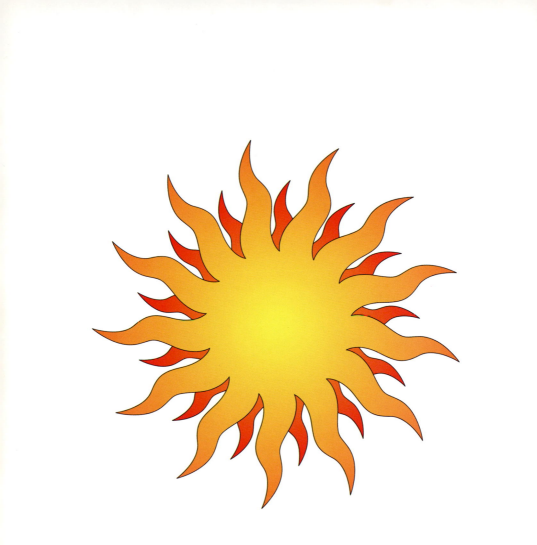

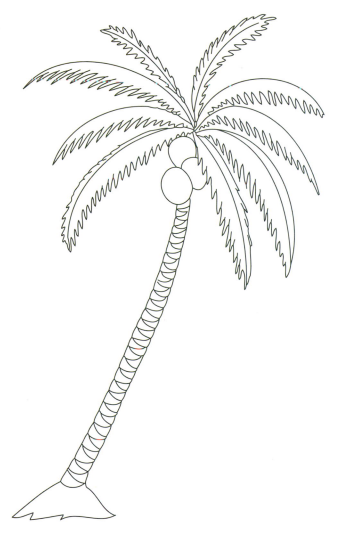

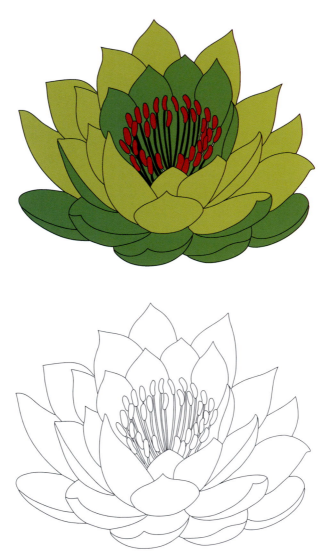

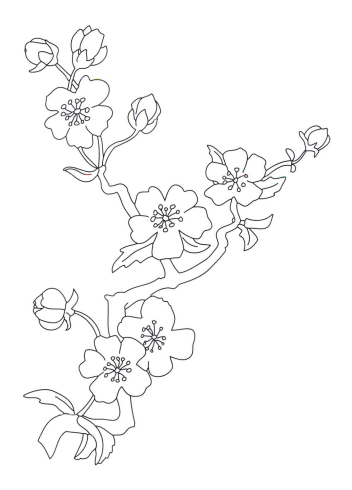

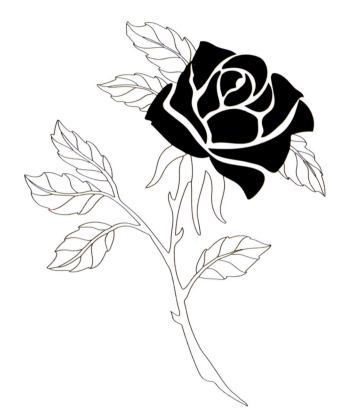

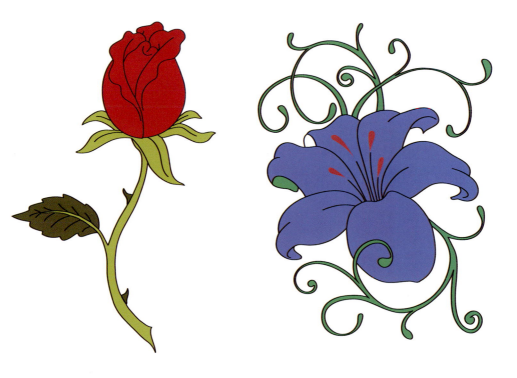

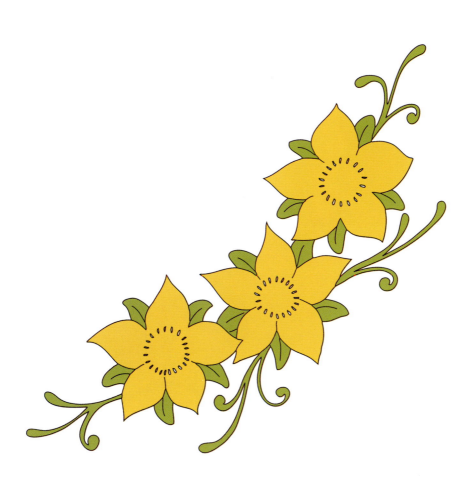

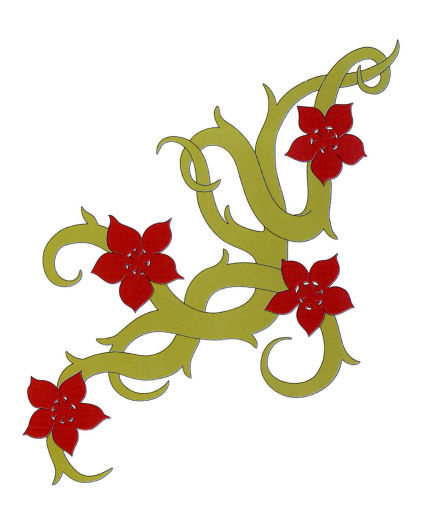

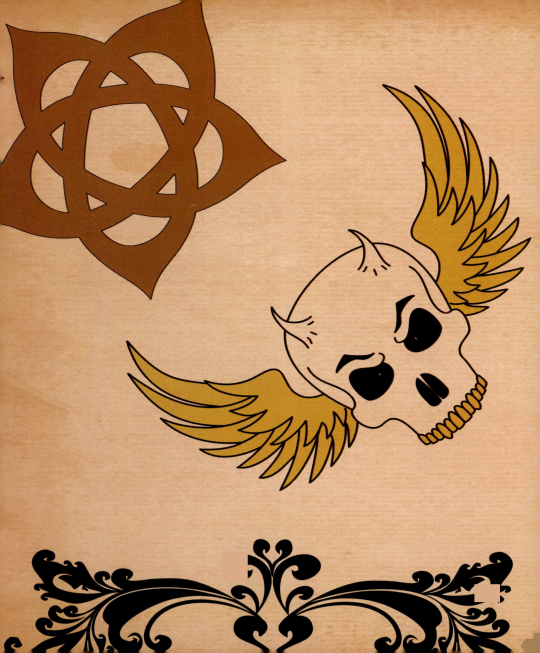

CLASSIC TATTOOS

Old-school classic tattoos, often derived from nautical and folklore traditions, include such motifs as hearts and banners, skulls, daggers and international symbols, such as the wheel of life, cross and mandala. This chapter takes a look at the seafaring tattoos of sailing ships, skulls, anchors, banners inscribed with loved-ones' names and mythical creatures, as well as romantic hearts and flowers. Nautical stars, particularly the Southern Cross, as well as compasses in different forms, were tributes not just to ancient navigational methods but also as an appeal for guidance and protection. Luck and superstition are also recurrent themes in classic tattoo art, and may take the form of dice, horseshoes or the shamrock. The mermaid, one of the world's most irresistible mythological characters, with her ability to lure sailors to their death on the rocks, made her feared, adored and tattooed as enthusiastically as the banner tattoos that proclaimed love for sweethearts and family members.

Traditionally, skulls signify a defeat over death or a conquering of the enemy, and a skull with a serpent crawling out of the eye sockets represents knowledge and immortality. Mandalas and wheels of life are also popular designs that denote the eternal circle of birth, life and death, and they are connected to all the great religions of the world. Similar designs are the pentacle – associated with witchcraft and knowledge – and the cross – one of the oldest religious symbols and linked to the sun, sky, the passage of time and most solar deities.

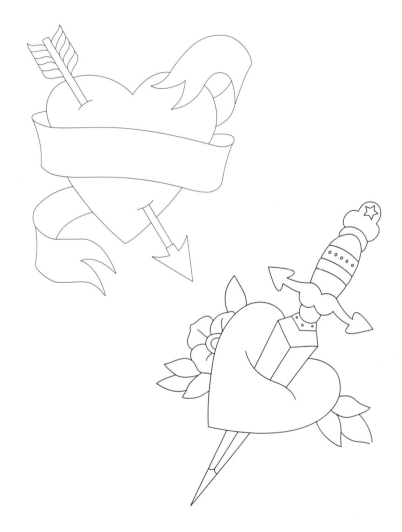

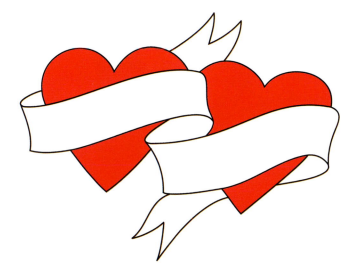

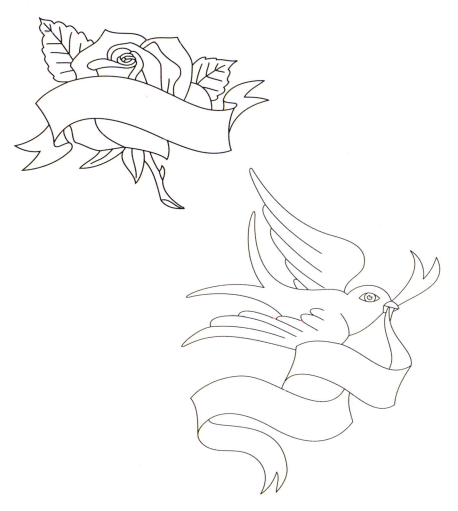

CLASSIC TATTOOS

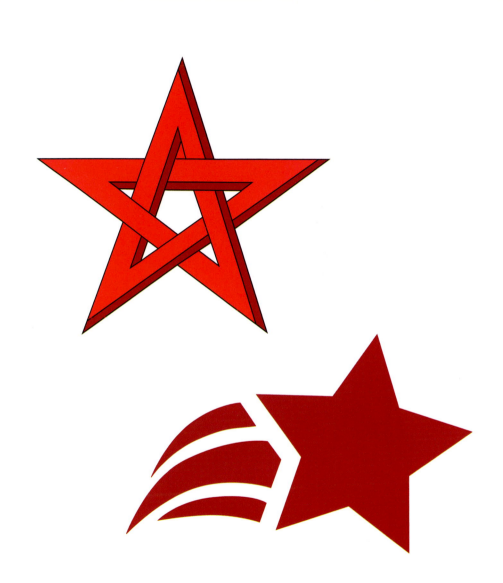

 CLASSIC TATTOOS

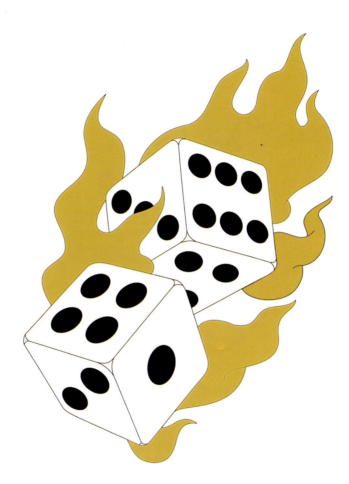

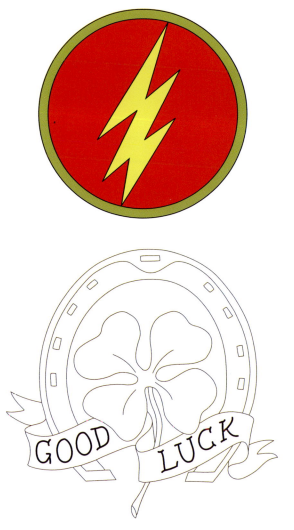

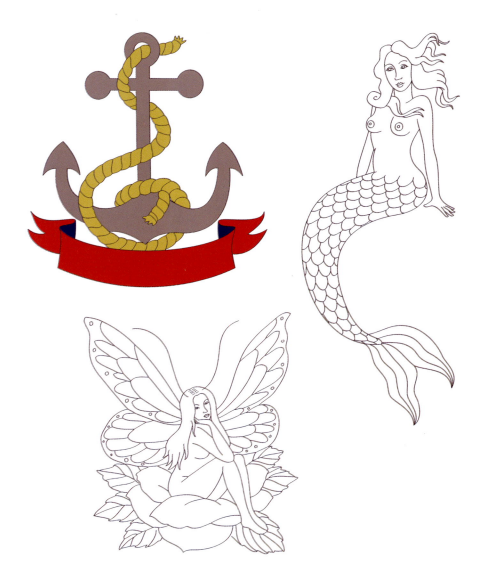

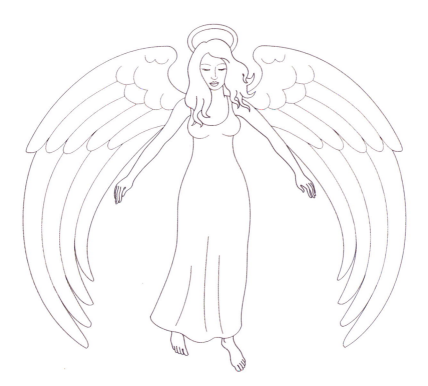

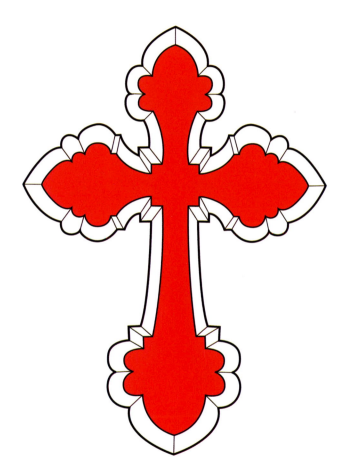

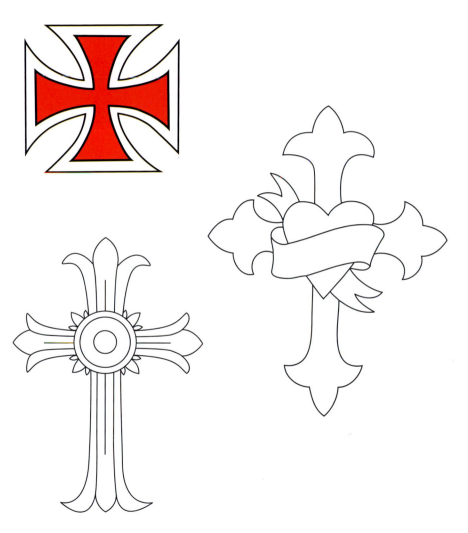

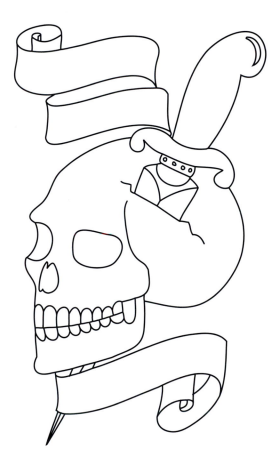

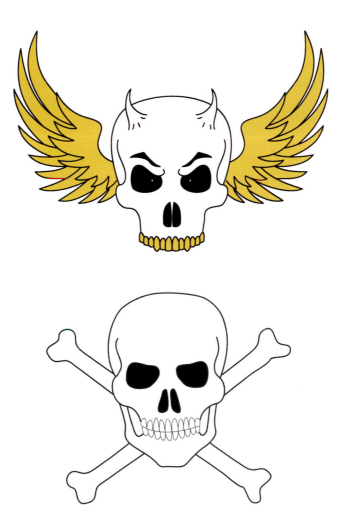

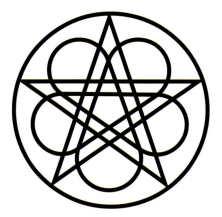

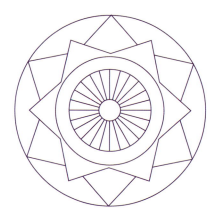

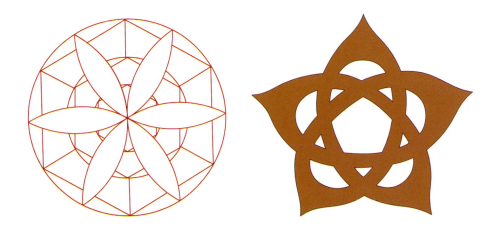

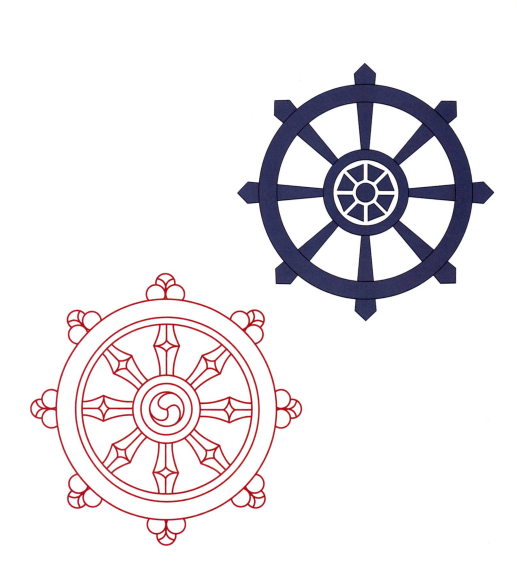

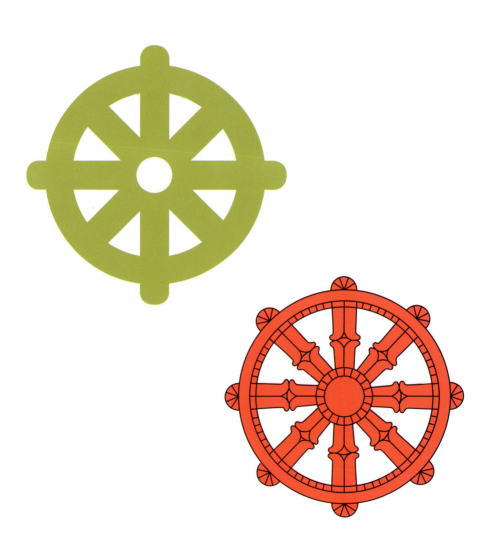

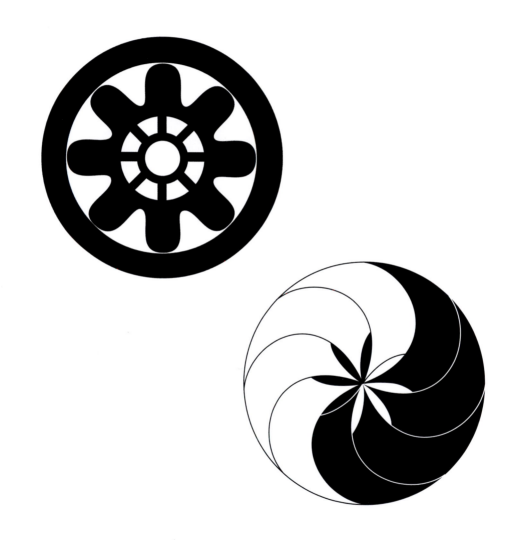

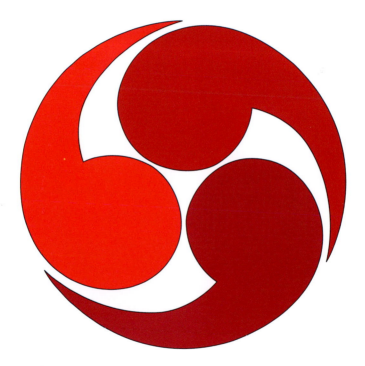

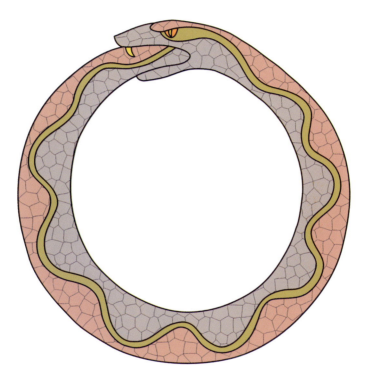

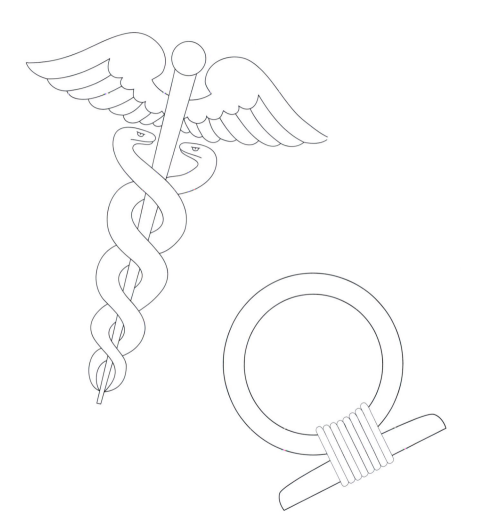

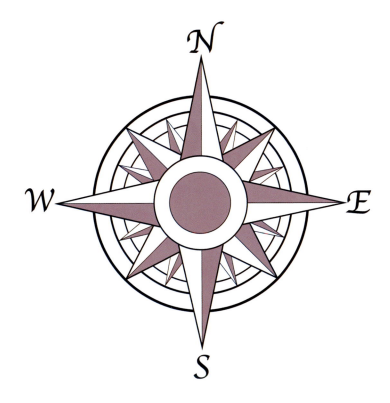

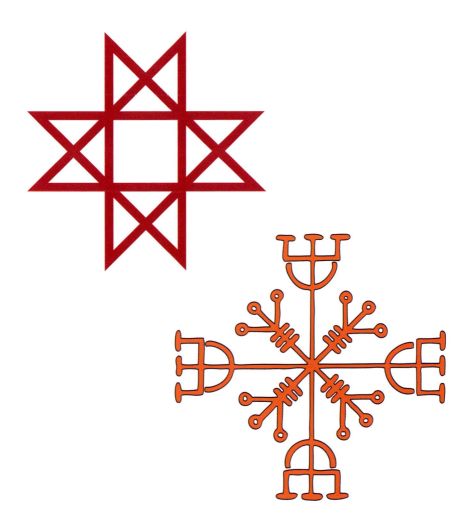

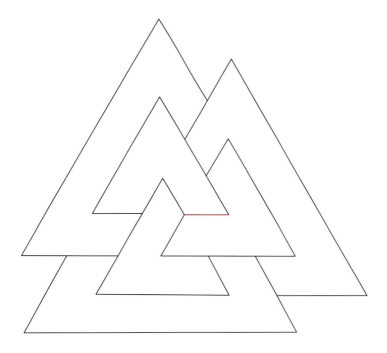

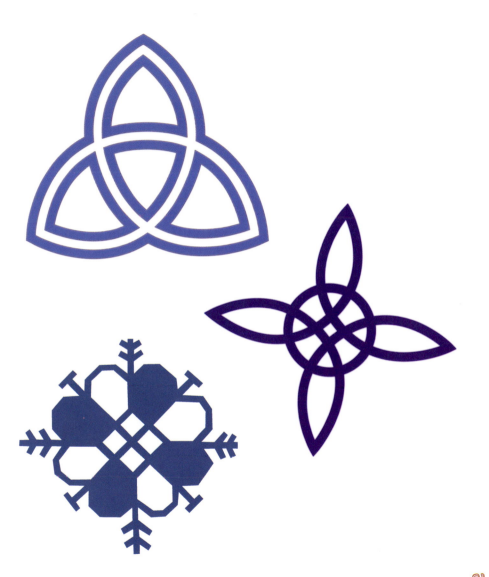

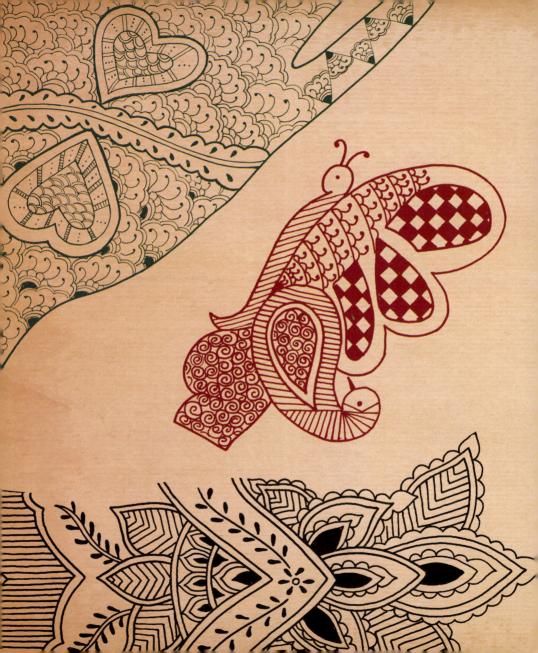

MEHNDI DECORATION

Mehndi – henna in English – is best known in the West as a reddish-brown hair dye with conditioning properties that make it a popular ingredient in haircare products. In the East, however, it has also traditionally been used as a skin colourant and is central to the long tradition of temporary tattooing, which is the subject of this chapter.

Mehndi is the dried and powdered leaf of the dwarf shrub *Lawsonia inermis*, a member of the loosestrife family, *Lythraceae*, which grows to a height of about 3 m (8½ feet). A distilled water preparation used for cosmetic purposes is made from its small, sweet-smelling, pink, white and yellow flowers. It grows in hot climates and is supplied mainly from Arabia, Iran, Ceylon, India, Egypt, Pakistan and Sudan, though it may also come from China, Indonesia or the West Indies.

The history of mehndi goes back 5,000 years. It is said to have been used in ancient Egypt to colour the nails and hair of mummies. In the twelfth century, the Mughals introduced it into India, where it was most popular with the Rajputs of Mewar (also known as Udaipur) in Rajasthan, who mixed it with aromatic oils and applied it to the hands and feet to beautify them. From then on mehndi has been regarded as essential to auspicious occasions, particularly weddings.

It was only after reaching India that mehndi gained real cultural importance, its use by the rich and royal making it popular with the people. Servants who had learnt the art of mehndi by painting the hands and feet of princes and princesses (with fine gold or silver sticks) were much sought after in towns and villages for their skills. As the use of mehndi spread, recipes, application methods and designs grew in sophistication.

In Persian art – most notably in a famous series of miniatures dating from between the thirteenth and fifteenth centuries – women taking part in wedding processions and dancers are depicted with mehndi decoration on their hands. It has been suggested that in the scorching heat of Arabia, mehndi was often used on the skin for its coolant properties.

Hindu goddesses are often represented with mehndi tattoos on their hands and feet, and Muslims have used mehndi since the early days of Islam. It is said that the prophet Muhammed used it to colour his hair as well as, more traditionally, his beard. He also liked his wives to colour their nails with it. That Muhammed was and remains a model of perfection for Muslims has ensured the continuing popularity of mehndi as a decorative art within Islam.

With the passing of centuries, mehndi has gained in significance in cultures within the Middle East, Asia and north Africa. All of these communities use mehndi for the same purpose: to decorate and beautify; however, each one has its own unique designs, inspired by indigenous fabrics, the local architecture and natural environment, and individual cultural experiences.

In south India, a circular pattern is drawn and filled in in the centre of the palm. Then a cap

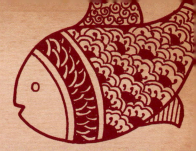

is formed on the fingers, as if they had been dipped in mehndi. This design is used by most Asian elders, as in the early days before cones were available it was simple to apply. It is this design that is used by south Indian classical dancers.

In north Africa, very intricate designs are developed around peacock, butterfly and fish images, which are completed with finely detailed patterns. The effect is that of a lace glove, as great attention is given to filling in the gaps that surround the main motif. Religious symbols are incorporated, such as the *doli*, a form of hand-pulled carriage used to transport the bride from her home to her in-laws' house in the days before cars. The lotus is also popular.

Many people confuse Pakistani with north Indian designs, because both are intricately applied to give a lacy glove-like effect. In fact, however, Pakistani designs are a blend of the north Indian style and Arabic motifs – flowers, leaves and geometrical shapes. This choice of motif derives from religious teachings: Muslims may not pray with figurative representations on the body, and so do not employ designs depicting human faces, birds or animals.

Arabic patterns are well spaced on the hand, and traditionally completed by dyeing the nails with mehndi to give a deep stain. Sudanese patterns are large bold and floral, with geometric angles and shapes, normally created with black henna. The motifs on the following pages show a huge variety of the design forms of mehndi, and further instruction on application is available on pages 250–5.

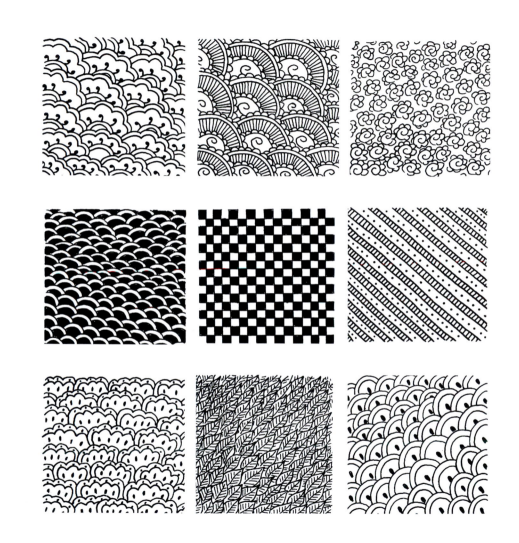

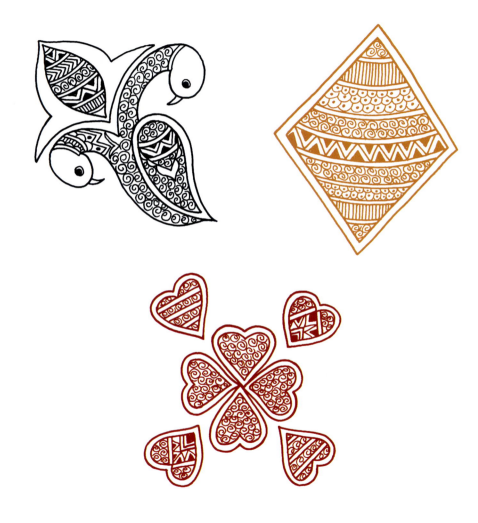

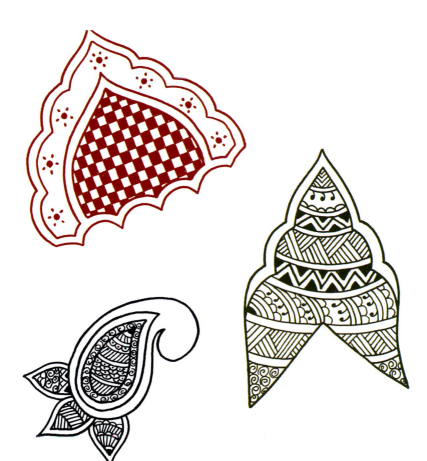

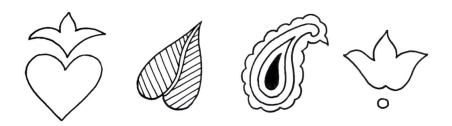

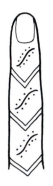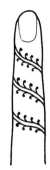

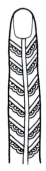

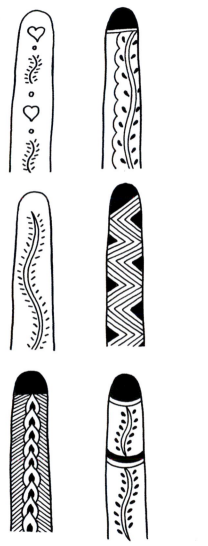

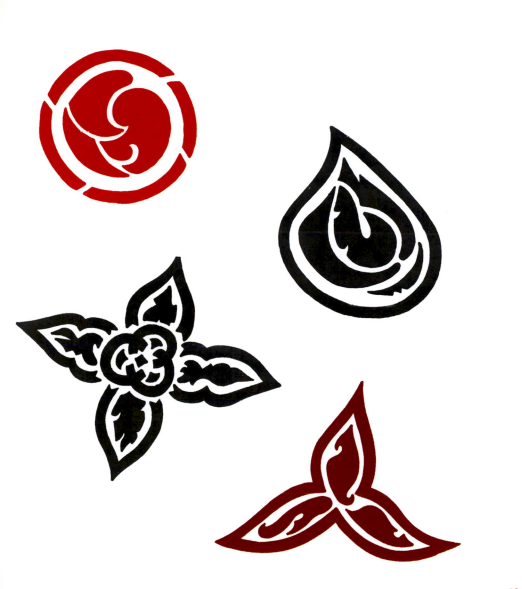

MEHNDI DECORATION

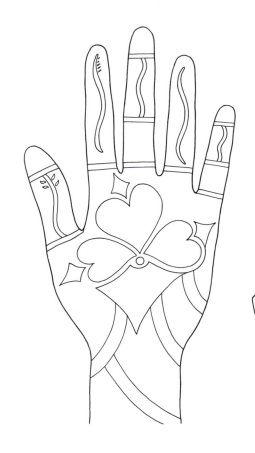
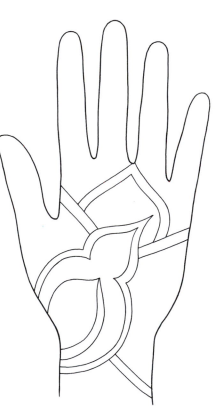

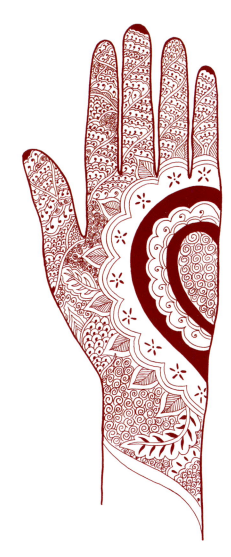

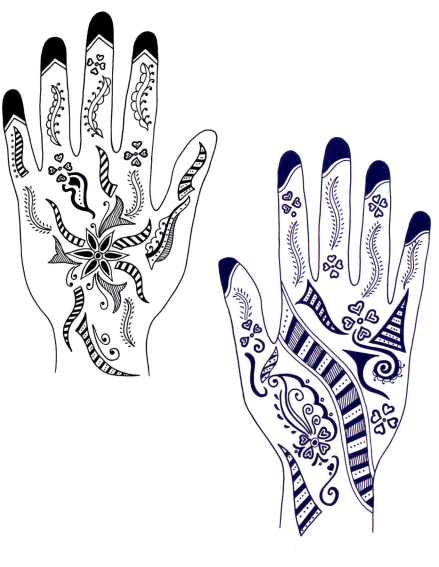

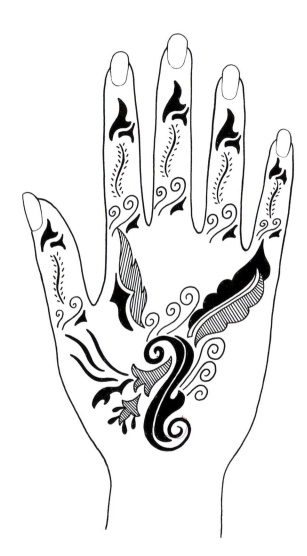

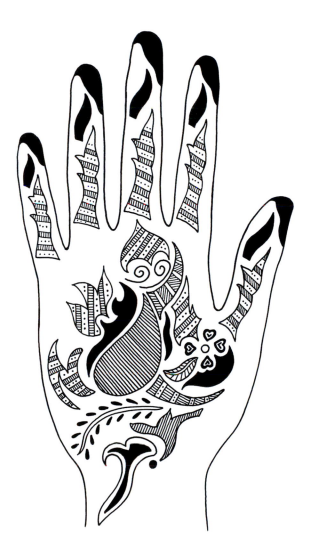

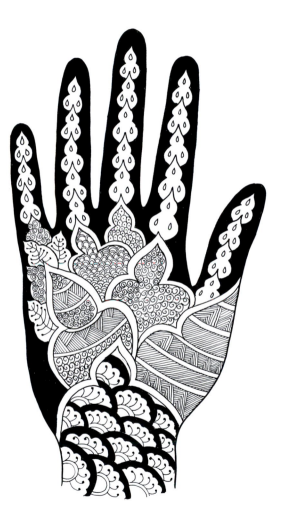

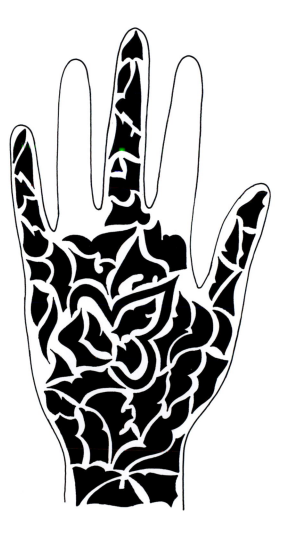

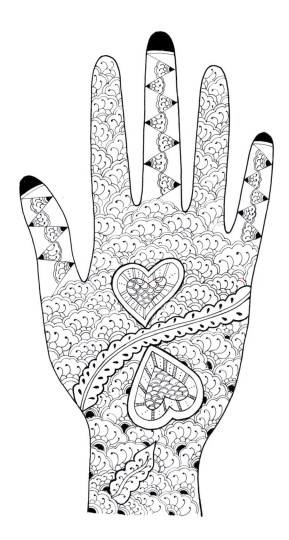

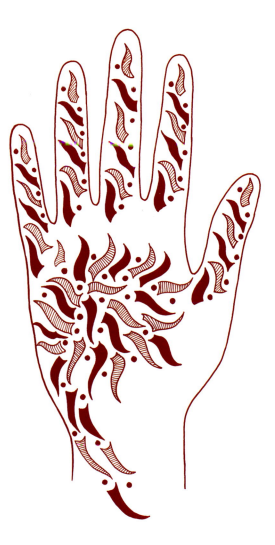

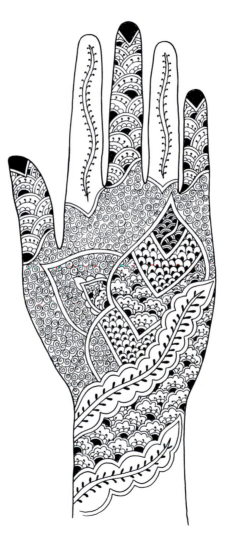

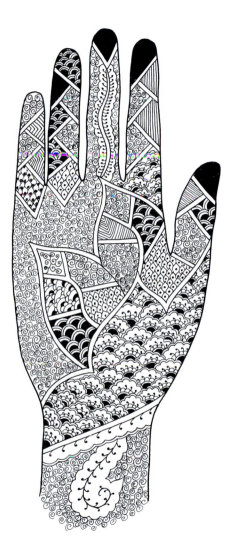

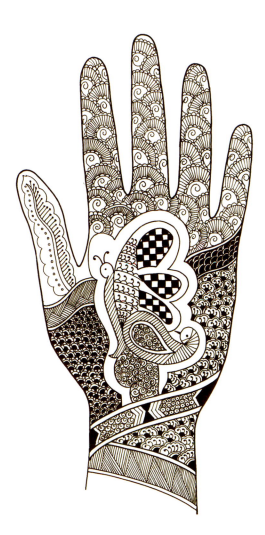

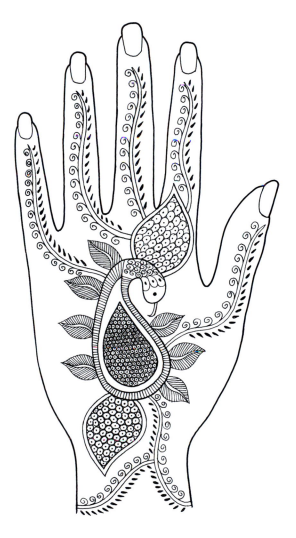

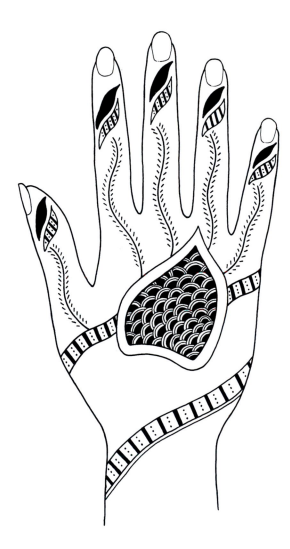

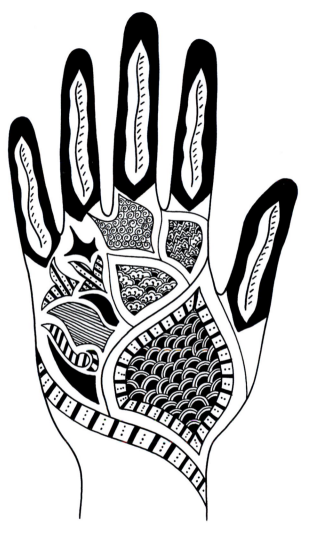

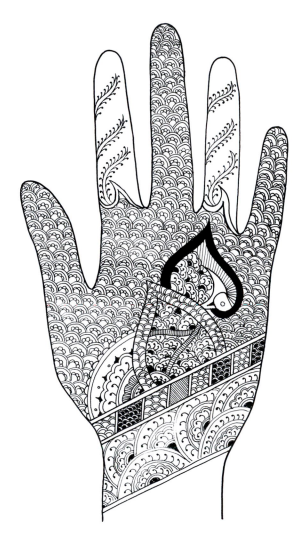

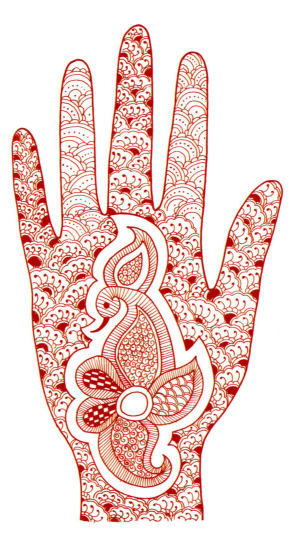

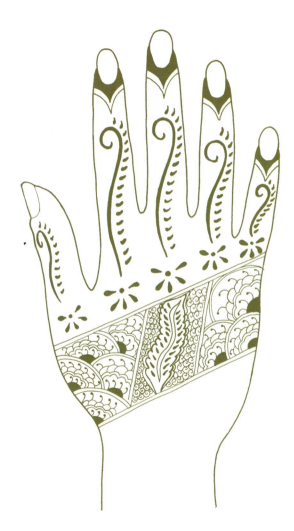

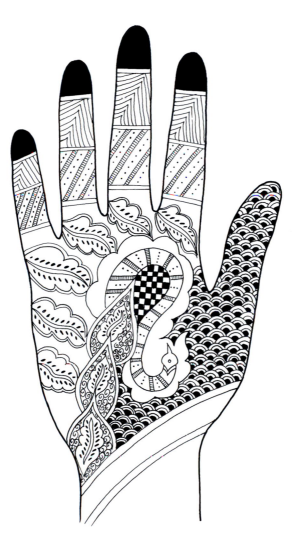

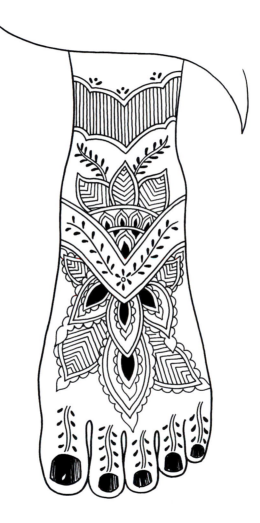

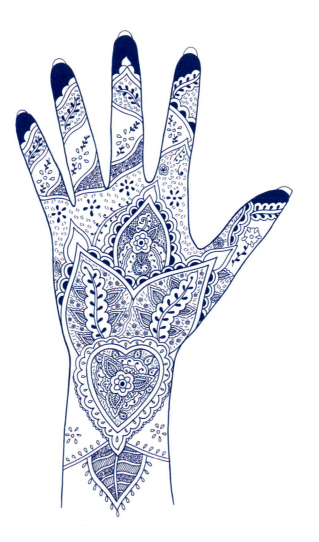

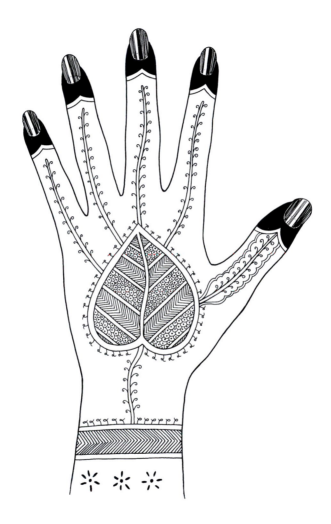

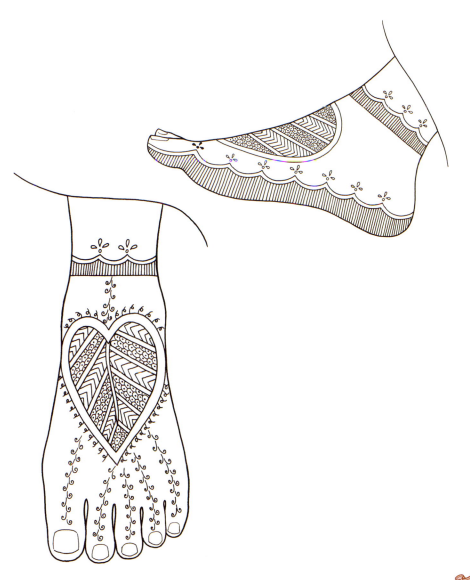

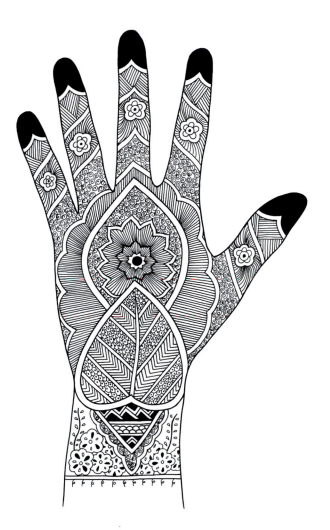

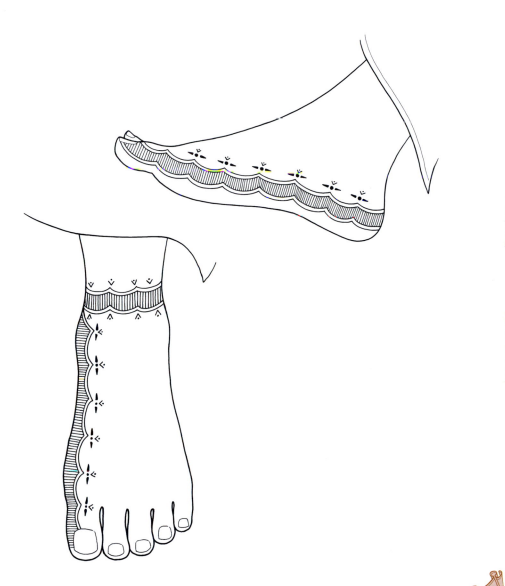

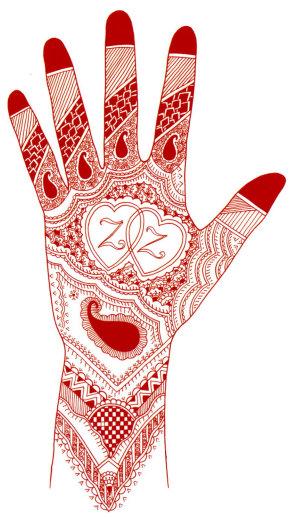

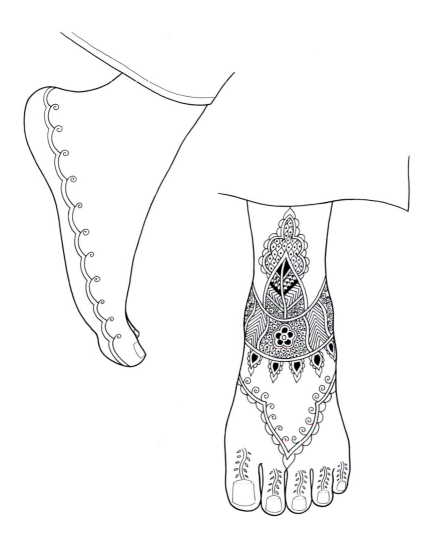

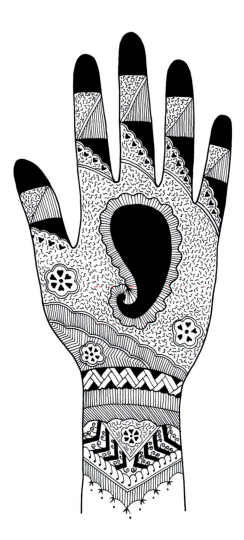

MEHNDI DECORATION

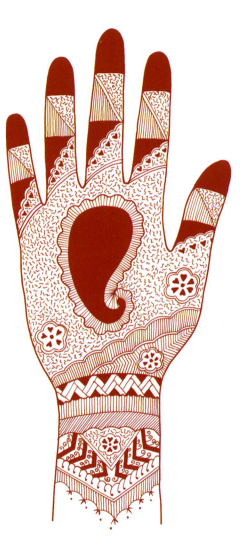

MAKING YOUR OWN DESIGNS

The first thing to say is the most obvious: do not try to tattoo yourself. Even though you won't kill yourself, probably, you will be giving yourself an ugly, messy and embarrassing collection of scar tissue to remind you just how stupid a mistake can be for the rest of your life. On the other hand, designing a tattoo to be put on professionally can be a deeply spiritual and self-affirming exercise.

The first thing to do is to decide where on your body you want the tattoo. Different designs work better on different parts – a blackwork design needs to be fairly large and visible from a distance to achieve full impact, so would not usually work as a small design on the ankle, for instance. Similarly a small design would look lost in the middle of an undecorated back. Having chosen the position and scale for your design the next step is to choose the style. Once you know the style, it is a very good idea to look for more examples in your local library. You can try searching the web, but for images libraries tend to be better. And when it comes to colours you can do whatever you want. Up to the last thirty years, tattoo dyes were not very stable, and tended to fade and bleed (spread out), leaving a washed-out memory of the original after a few years, but this is no longer the case. Of course if you want to look like a traditional tribal tattoo, you must follow Henry Ford's advice: you can choose any colour, as long as it is black. Only a handful out of the thousands of tribes used red for tattooing, but no

other colours were ever used as no naturally occurring pigment was found that was stable and sterile in any other colours. White ash and clay were used for body painting, to create a sharp contrast among particularly dark-skinned tribes, but never tattooing.

Next comes the hard and fun part, depending on your talents: the drawing of the design. You have access to tools that tribal tattooists couldn't even dream of – tracing paper, photocopiers, computers – all of which can help you with your design.

Once you have a design that you are happy with it is always a good idea to put it away out of sight for a while – the longer the better, so that you can come back to it with a changed perspective. If you do not like it as much, see if you can see why and then play around with it until it looks better. This is often done by changing just one line: thinning or thickening it, changing the curve, or similar, is enough to change the balance and dynamic of the entire design.

Now, just to test your resolve – remember a tattoo is for life, not just a party – make a fake tattoo version of it to show trusted friends for a day or two. This technique can be used to transfer complicated designs to the skin. These can then be filled in with any type of body paint.

If you are still happy with it take a copy of the design down to the best tattooist in town (or one whose work you have seen and admired). And do it.

Create and enjoy.

Body Painting

All of the techniques and materials listed below are designed to be safe to apply to the skin, but every person is different and some may develop an allergic reaction to some paints or dyes. When trying new paints, or painting a new person, always test for a reaction by applying a small amount of the paint to the inside of the elbow and leaving it for an hour or so. If there is no reaction – and there almost never will be – then it should be safe to cover larger areas with the paint. Body paint is temporary and can be cleaned off, rather than dyes, which stain the skin and so last much longer. Theatrical make-up such as cake make-up is harder to apply and remove and easier to smudge in normal use. If you are painting these designs for theatrical or film use, a theatrical make-up manual should be consulted.

Having chosen your design and drawn it to the scale you want it, you can trace it onto a piece of waxed paper, using a thin dark felt-tip pen. The lines will only be patchy but will be useable as a guide. Another method you can use is to put the sheet with your design on something soft (a piece of cotton or several sheets or waste paper) and prick holes with a pin along all the lines. Place it on the skin and rub the design with a sponge dipped in paint. This will give you a dotted outline to follow.

The second step is to fill in the areas with the colours of your choice, painting up to the outline that you marked. So as not to smudge the parts that are already painted, do not rest your hand on the skin when painting. Next you paint in the outline in a darker colour, painting it so that the line should follow the edge of the area that you previously painted, so that half is on paint and half on skin. The reason for doing the outline last is so that it is an even width throughout.

TOOLS

Brushes

For these designs it is best to have four brushes: one thin round brush for fine detail and touching up smudged areas, one medium round brush for the outlines, one medium flat brush for filling in areas and for painting lines that vary in width (for a pen-like line) and, one large round brush for filling in large areas of colour.

All these brushes should be as soft as possible so as not to irritate the skin. Soft brushes also hold the paint better, make smoother, more even lines and are easier to clean. Sable and squirrel (artificial if possible) are the best. After use they should be cleaned in warm, soapy (not detergent) water, unless the instructions on the paint ask for special cleaning requirements, and kept in a jar with the bristles upwards, so that they do not bend.

When painting always remember to rinse the brushes in clean, warm water between different colours or they will become muddy. Always try to draw lines on one smooth stroke, rather than a lot of short strokes, as this gives a much smoother line that flows.

Face Paints

The most obvious choice of paints are water-soluble face paints because they are relatively cheap and designed to be painted on children, and so are non-toxic. They are available from most large toy shops and department stores and come in small palettes or individual pots. They are easy to apply and dry quickly. Some brands smudge much more easily than others (it depends on the amount of grease in the paints), so it is worth experimenting to find the best available locally. Face paints come in a wide range of bright colours and are opaque.

Textile Acrylics

These are designed for airbrushing on cloth, but they seem to work well on skin and are non-toxic. They dry quickly and don't rub off easily. Because they are made for textiles they are not as prone to cracking and peeling in the way that ordinary acrylics do. Yet they still wash off easily in soap and water. While designed for airbrushing, they still work well with brushes. Airbrushing is useful for smooth shading, especially over large areas or when stencilling.

Cleaning Up

Cold cream and cosmetic cleansers are the best things for removing water-based as well as oil-based paints. Baby wipes can also be very effective at removing water-based paints. Smooth a layer of cold cream over the design, leave it for a minute and then gently rub it off with cotton wool balls or soft tissues. If necessary, repeat until all of the paint has gone. Patience does the job much better than brute force. If you get paint on your clothes, wash it out with cold water followed by detergent if it is water-based. If it is oil-based, the detergent should be used first.

FAKE TATTOOS

If you want to make a temporary tattoo, there are two fairly simple methods.

First, using a dark blue or black ballpoint pen, copy your design (in reverse if you want it a particular way round) onto the smoothest, shiniest paper you have. Waxed paper is the best as you can trace the design through it, but ballpoint pens tend not to work well on it. Then place the design face down on the body and rub it from behind with cotton wool dipped in acetone (nail polish remover). This will make the ink transfer to the skin. If the ballpoint pen does not work on your chosen paper, you can use a felt pen, but the image will be much fainter and less sharp. With the outline marked you can now fill in the areas with colour.

For a temporary tattoo that is quick ad easy to wash off, the easiest things to use are children's felt-tip pens. Being translucent, they do not obscure the surface of the skin like paints, but let it show through like real tattoos. Because of the area that will need to be covered, the broader the nib of the pen the better. The best are chisel-tipped pens as they can be used for fine lines as well as filling in areas.These designs are easy to wash off with soap and water, but as the inks are soluble they should only be used when there will not be any water or sweat to make them run and fade.

STENCILLING

Stencilling is suitable for covering large areas with a repeated pattern, or if you want to paint several people with the same design. It also allows you to create subtler and more creative shading and when airbrushed in several colours it looks very impressive.

Probably the simplest way to make a stencil is to draw your pattern to its final size and colour it in as you want it to be. Trace the outline onto tracing paper or photocopy it onto copy paper. Using low-tack spray adhesive, stick it onto your stencil paper (available at art and craft shops). You can make your own stencil paper by rubbing both sides of a sheet of card with cotton wool dipped in oil to make it waterproof. Use as little oil as you can to give it an even covering.

Referring to your coloured version, cut out all the pieces of one colour, cutting through both the copy and the stencil. Carefully unpeel the coy from the stencil and stick it to a second stencil. Cut out all the pieces of the second colour, and so on for each of the colours you have chosen.

You can stick the stencils to the skin using the same spray adhesive. Then, using an airbrush, stencilling brush, sponge or cotton wool ball, apply the paint. Repeat this with each of your stencils, taking care to align the different colours as well as you can. When you have finished you can add an outline with a brush, or any other decoration you want.

A final note on colours: on Caucasian skin, black is always used for most outlines to give the design enough contrast to stand out, nothing else gives the dramatic impact that suits tattoos. Red is the second most used colour because of its strength – red attracts the eye more than any other colour. Blue tends often to be used as a form of shading and softening of the black outline on the inside of the design, while the outside edge is still sharp black. Greens and purples tend to be only used to colour in pictures, as on their own they are associated with bruising and ill-health. Yellow is even more rarely used as it not only looks sick and jaundiced, but also does not stand out on white skin.

RECIPES FOR PREPARING YOUR OWN MEHNDI

Pre-mixed mehndi cones are always a good way of beginning the art of mehndi, as you can more or less get straight into it. Once you have gained confidence and would like to try making your own mehndi, just follow any one of the recipes below. I have included a few different versions; the first one is the most commonly used, and the others are from friends who have tried them or discovered them while travelling. It might be better to try the main recipe first, and then go on to try the others when you have gained some experience.

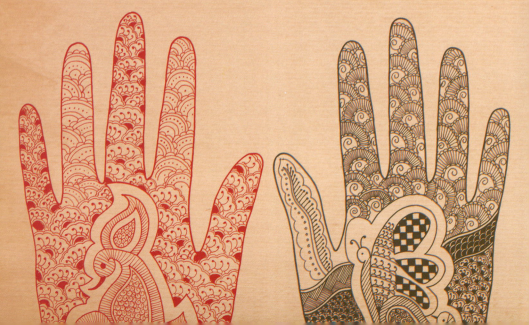

Ingredients

These ingredients are needed for all the recipes:

Empty plastic cones (see Making a Plastic Cone, page 255) • Mehndi powder • Lemon juice •
Sugar • Tamarind paste • Eucalyptus oil • Clove oil • Teabags • Coffee • A fine sieve

RECIPE ONE

1. For the best results, sieve the mehndi at least two or three times. Although the powder looks
fine, it often contains small pieces of bark (remember it comes from a plant). These particles,
if not removed, may clog the cone later, presenting a problem when you are tattooing.

2. Make up a mixture of two teabags, two teaspoons of coffee and two teaspoons of
tamarind paste (available from Asian food shops). Bring this mixture to the boil in three-
quarters pint of water, and let it simmer for about an hour, then allow it to cool down.
Sieve the mixture to ensure that there are no particles left.

3. Add this mixture to the sieved mehndi and stir. The mixture should be the same
consistency as icing sugar which is ready to pipe through a bag, so add the water
slowly, as you can always add more later.

4. Leave the mixture to mature for about three hours in a cool dry place.

5. Just before you spoon the mixture into the plastic cones, add five drops of eucalyptus oil,
and five drops of clove oil. Mix in well and then transfer to your plastic cones.

RECIPE TWO

This recipe is popular in Morocco.

Additional ingredients:

Rosewater • Orange flower-water

1. Prepare the mehndi powder as in Step One for Recipe One.

2. Mix together one cup of brewed black tea which has been left overnight with half a cup of freshly squeezed lemon juice.

3. Add this mixture to the sieved mehndi, and then mix well as in Step Three for Recipe One. Once mixed, leave for up to three hours.

4. Before you apply the mehndi, wash the area you are going to tattoo with equal parts of the rose and orange flower-water. If this is difficult, use a cotton pad to cleanse the area with the flower-water mixture.

5. Finally, rub eucalyptus oil into the area to which the mehndi is to be applied. This helps the skin to accept the colour, and deepens the stain.

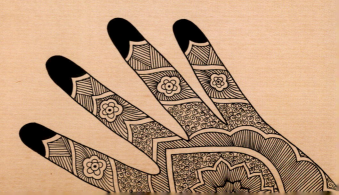

RECIPE THREE

This is a very quick but effective recipe.

1. Prepare the mehndi as you did in the previous recipes.

2. Add one cup of freshly squeezed lemon juice and about 10 drops of eucalyptus and clove oils to the mehndi mixture. Again, remember that the consistency should be that of icing sugar, so if you find the mixture is too lumpy, add the required amount of lemon juice to make it the right consistency. This mixture is almost immediately ready to be piped through your plastic cones.

MEHNDI BEFORE AND AFTER CARE

These are some useful tips on mehndi care both before and after application. By following them, you are sure to get a good colour from your mehndi design.

- Prior to the mehndi application, cleanse the area to be tattooed to remove any residue that may be on the skin. Either wash the area or wipe it with a cotton pad, soaked in water.

- Remember that once you have cleansed the area, you need to apply a pre-application oil such as eucalyptus to increase absorption of the mehndi and ensure a deep stain.

- If you are applying mehndi to the soles of your feet, remember that you will get henna everywhere if you put them on the floor. Make sure that you don't tattoo your feet when you're planning on moving around!

- Once you have completed your chosen design and the mehndi is beginning to dry, apply a mixture of two parts lemon juice to one part sugar, mixed well. This will help the design to stay on the skin for however long you require. Because it is a sticky mixture, it adheres the mehndi to the skin. It also keeps the mehndi moist for longer, which will help in developing the colour.

- Once the mehndi has been on the skin for about eight hours, scrape it off using a butter knife or by rubbing your hands together. Remember to do this over a sink. Once the mehndi is removed, rub some mustard oil into the skin to help seal in the colour and encourage it to develop into a darker stain.

- The longer you leave the mehndi moist, the deeper the colour that will develop.

- Do not expose the tattooed area to water for about twelve hours.

MAKING A PLASTIC CONE

If you can't find ready-made cones, you can try making your own plastic mehndi cone. This is easy to do and will only take a few minutes.

YOU WILL NEED

Durable plastic (such as food bags or clear carrier bags), scissors, strong adhesive tape.

1. Cut a rectangle approximately 16 cm x 12 cm into your plastic. Start to roll the plastic inwards from the left, shaping it into a cone. Ensure that you do not leave any gaps at the bottom.

2. Once you have formed the cone, make sure you have secured it at the top and bottom and sealed the edges.

3. Fill your cone about three-quarters full of mehndi using a small spoon.

4. Fold both sides inwards then downwards about three times, and secure with tape.

5. Use a pin to make a tiny hole at the bottom of the cone. Your mehndi cone is now ready to use.

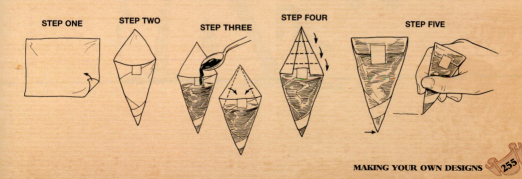

STEP ONE STEP TWO STEP THREE STEP FOUR STEP FIVE